Circle : constructive art in Britain 1934–40

edited by Jeremy Lewison

Kettle's Yard Gallery

This catalogue is published to accompany the exhibition
'Circle : international survey of constructive art' held at
Kettle's Yard Gallery from 20 February to 28 March 1982.

Kettle's Yard Gallery is subsidised by the Arts
Council of Great Britain

Kettle's Yard Gallery
Northampton Street
Cambridge
CB3 0AQ

Exhibition organised by Jeremy Lewison,
assisted by Ann Compton
© Kettle's Yard Gallery and the authors 1982

ISBN 0 907074 12 X

Photographs by A J Hepworth, Tate Gallery,
British Council, A C Cooper Ltd, Annely Juda Fine Art,
Studio St Ives Ltd, Courtauld Institute of Art, Barbara Luthy.
Catalogue designed by Sally Jeffery.
Typesetting by Anglia Photoset, Colchester.
Printed at the Lavenham Press, Lavenham, Suffolk.

contents

5 Foreword *Jeremy Lewison*
7 Acknowledgements
9 Introduction *Leslie Martin*
11 Circle : the theory and patronage of constructive art in the thirties *Jane Beckett*
33 Circle and the constructive idea in architecture *Nicholas Bullock*
43 Art and life *John Gage*
47 Events and exhibitions 1933–39

Reviews of Circle

48 *New Statesman* July 1937
49 *Times Literary Supplement* July 1937
50 *The Listener* August 1937
50 *London Mercury* September 1937
51 *The Studio* November 1937
51 *Burlington Magazine* 1937

Articles and extracts

53 Herbert Read, *Axis 1* January 1935
54 Geoffrey Grigson, *Axis 1* January 1935
55 S John Woods, *The Studio* June 1936
56 Myfanwy Evans, *Axis 6* summer 1936
57 S John Woods, *Axis 6* summer 1936
59 John Piper, *Axis 7* autumn 1936
59 Naum Gabo, *The Listener* November 1936
61 J M Richards, *Axis 4* November 1935
62 Herbert Read, *The Listener* October 1935
63 Philip Hendy, *London Mercury* November 1935
65 John Summerson, *The Listener* March 1939
66 J M Richards, *Architectural Review* September 1934
66 S John Woods, *Axis 7* autumn 1936
67 Henry Moore, *The Listener* August 1937
68 William Gibson, *London Mercury* November 1937
69 Anthony Blunt, *The Spectator* October 1937
69 Herbert Read, *Art and Industry*, 1934
70 S John Woods, *Axis 5* spring 1936
71 Herbert Read, *The Listener* July 1937
72 Reginald Blomfield, *Modernismus*, 1934
72 Marcel Breuer, *Architectural Review* April 1935
73 J M Richards, *Architectural Review* December 1935
76 Wells Coates, *Architectural Association Journal* April 1938
77 J D Bernal, *RIBA Journal* June 1937

The catalogue

80 Painting and sculpture
83 Architecture
87 Art and life

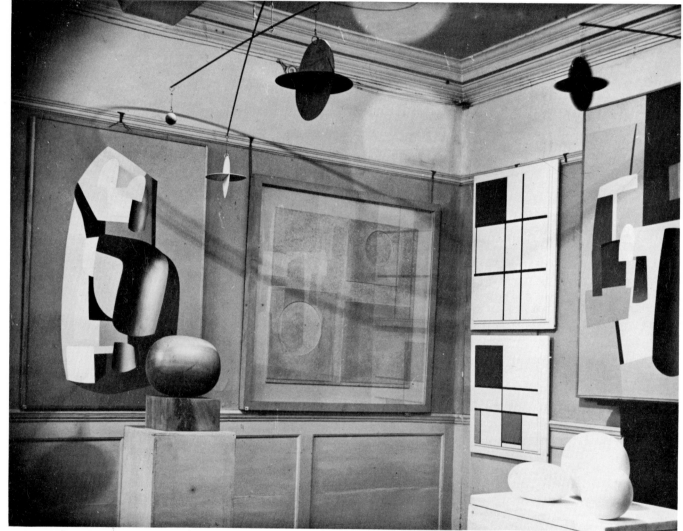

Abstract & Concrete exhibition, Oxford, 1936

foreword
Jeremy Lewison *curator, Kettle's Yard*

In 1937, under the editorship of J L Martin, Ben Nicholson and N Gabo, Faber and Faber published *Circle: international survey of constructive art*. The initial proposal had been for a magazine and when Fabers accepted it for publication as a book, it was on the understanding that a sequel would follow in the event of sufficient new material becoming available. As such, *Circle* was the third in a series of important publications on the market in the thirties. Its emphasis, however, was different from those of *Unit One* (1934) and *Axis* (eight instalments January 1935 – early winter 1937) and in particular can be seen as a replacement for the latter which had begun its life as 'a quarterly review of abstract painting and sculpture' but which by the end had begun to renounce its bias towards abstraction. *Circle*, as its subtitle implies, had a specific brief: to highlight aspects of constructive art, architecture, design and, broadly speaking, life. In its use of the word 'constructive' it attempted to embrace a wide cross-section of artists, architects and writers who might not have been included under a 'constructivist' umbrella. 'Constructivist' was too restricting as a descriptive term for a journal which sought to publicise an attitude to life. Mondrian who considered himself to be a neo-plasticist would never have accepted the 'constructivist' label. 'Constructive', the editors believed, was an all-embracing, neutral term loose enough to encompass the leading abstract artists in this country; for essentially *Circle* appears to have aimed at highlighting the British contribution to the European abstract movement and at setting it within a wider European context. It marks an increased confidence on the part of British artists and architects and a desire for international recognition. It also reflects the stimulus provided by the arrival of refugees from the Continent, notably Naum Gabo, Walter Gropius, Berthold Lubetkin, László Moholy-Nagy and, slightly later, Piet Mondrian.

Artists, architects and writers were invited, either by letter or through personal contact, to submit contributions to *Circle*, and by the response of Massine, it appears that some likely contributors were sent questionnaires. Responses came in various forms: written, documentary and photographic. Frequently the material supplied was simply what happened to be close at hand and did not necessarily demonstrate conclusively an overriding interest in constructive art. After the initial selection of contributors, very few editorial decisions appear to have been made other than in the actual layout of photographs which was the responsibility of Barbara Hepworth and Sadie Speight. The enormous variety of works and attitudes which resulted from this approach may also reflect more generally the range of opinions surrounding the discussion of the issue of abstraction.

It remains curious that a journal whose contributors were in some cases refugees from foreign oppression could have had such an optimistic tone; particularly when unemployment was so high, when totalitarianism seemed to have a grip on Europe, when rearmament posed a serious threat to political stability and when the monarchic boat had been rocked by abdication. The explanation lies in the belief held by the editors and a number of the contributors that the 'constructive idea' would solve many of the problems of the world. As John Piper wrote somewhat cheekily in *England's Climate* (Axis 7 Autumn 1936, p 5): 'Constructivism is building for the future'.

Naum Gabo conceived of the 'constructive idea' as 'a general concept of the world, or better, a spiritual state of generation, an ideology caused by life, bound up with it and directed to influence it couse,' ('The Constructive Idea in Art', *Circle* p 6) and undoubtedly he saw in it a life-giving force. There was a need to begin again after the destruction of a war and, in artistic circles, after the 'annihilation the Cubist experiments had brought Art,' (ibid p 6). Constructive art represented, as it were, a *tabula rasa* of a new epoch. The idealism of artists such as Nicholson, Hepworth and Gabo, who considered art as a universal and therefore comprehensible language, was genuine. Constructive art, architecture and design would improve men's lives and in this respect *Circle* is a statement of faith and a rallying cry. We hope that this attitude will be made manifest by the exhibition and the catalogue.

In selecting works for the painting and sculpture section of this exhibition we have attempted to maintain the emphasis on the British contribution, with the exception of Naum Gabo whose sculptural and literary contributions to *Circle* were crucial. My initial proposal was to include only works which were illustrated in *Circle* but for practical reasons this became impossible. Many of the works have been destroyed and others are in foreign collections. Furthermore, it became increasingly apparent that as a survey *Circle* was a representative selection of work of the period and not an exclusive choice. We have elected, therefore, to exhibit works which display the 'constructive' spirit, and to follow the format of the book by including precedential works (Brancusi, Tatlin, Malevich and Pevsner) alongside the work which was contemporary at the time of the original publication. We have also sought to highlight some of the different inclinations we have detected in *Circle*. In my selection of the works I have been assisted by Jane Beckett to whom I extend warm thanks.

In hanging the painting and sculpture section we have attempted to crowd the gallery in a manner consistent with photographic records of the *Abstract and Concrete* exhibition organised by Nicolete Gray in 1936. In doing so

we hope to create something of the excitement and the flavour of the period. (*Abstract and Concrete* was hung by the late Sir Herbert Read and photographed by Arthur Jackson.)

The difficulties encountered in the selection of works of art have recurred in selecting exhibits for the architectural section. We felt that the variety of interests should be represented both photographically and by focusing on the work of a number of individuals whose work was regarded as particularly significant. Nicholas Bullock has selected this section of the exhibition and we are grateful to him and to Kim Randall and to Amy Sergeant for constructing the architectural models. In the design of the 'mock-up' interior, where we demonstrate the application to life of modern design, I have been well advised again by Nicholas Bullock.

John Gage has selected exhibits for the small art and life section where we have attempted to show the application of the 'constructive idea' to other cultural activities and the common ground it was believed to have shared with science.

Many people have been helpful to us during the course of the organisation of this exhibition. I would particularly like to thank Sir Leslie Martin for his co-operation and interest in the project and Nicolete Gray, Miriam Gabo and John and Myfanwy Piper for the information and hospitality they provided. Without them all, our researches would have been less fruitful. Arthur Hepworth, Jake Nicholson and Alan Bowness have also imparted useful information and we are grateful to them.

Many people and institutions have lent generously to this exhibition, some of whom wish to remain anonymous. We offer our thanks to them all for consenting to be deprived of such precious objects for the duration of the exhibition. Their names will be found elsewhere in the catalogue.

I would also like to thank the following people for providing much needed information and assistance: Gerald Bye, Michael Doran, Janice Fairholm, Sally Hames, Rachel Kirby, David Mitchinson, Jonathan Mason, Henry Moore, Benedict Read, Susan Rose-Smith and Timothy Stevens. We are grateful to Dick Papworth of the University Library for his work on the photographic display.

Ann Compton has worked diligently on many aspects of the exhibition and has helped considerably in the preparation of the catalogue.

Finally, I am grateful to my colleagues Jane Beckett, Nicholas Bullock and John Gage for the time and effort they have devoted to this project and for their stimulating contributions to the catalogue.

Acknowledgements

The following have lent works and items to the exhibition to whom grateful acknowledgement is made:

Annely Juda Fine Art, London
The British Council
Cambridgeshire County Council
Department of Physics, University of Cambridge
The Courtauld Institute of Art
Gimpel Fils, London
The Henry Moore Foundation
Royal Institute of British Architects, Drawings Collection
Robert and Lisa Sainsbury Collection, University of East Anglia
The Helen Sutherland Collection
The Trustees of the Tate Gallery
The Syndics of the University Library, University of Cambridge
Whitworth Art Gallery, University of Manchester

Best and Lloyd Limited
Pye Limited (Cambridge)

Martyn Chalk
Miriam Gabo
Nina Gabo
Nicolete Gray
David Grob
A J Hepworth
Jocelyn Morton
Mr and Mrs John Piper

and many private collectors who wish to remain anonymous

The documents, articles and extracts are reprinted with the kind permission of:

The Listener
The Studio Trust
New Statesman
Architectural Review
Architectural Association Journal
MacMillan & Co Ltd
The Burlington Magazine
The Times Literary Supplement
The Journal of the Royal Institute of British Architects
Ben Read on behalf of the Herbert Read discretionary Trust
Miriam Gabo

Sir John Summerson
S John Woods
Sir James Richards
Geoffrey Grigson
Anthony Blunt
John Piper
Myfanwy Piper
Henry Moore
Mrs Laura Cohn

Every effort has been made to contact copyright holders but in certain cases we have been unsuccessful. We would be pleased to hear from anyone whose permission to reprint we have been unable to obtain.

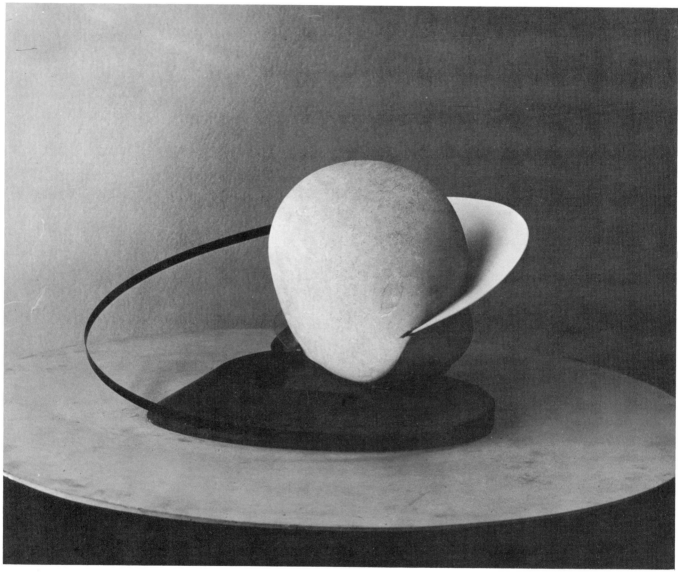

7 Naum Gabo *Stone with collar* 1933

introduction Leslie Martin

I have been asked to say something about the ideas that brought Circle into being. In the first place I think that it is important to say what was *not* intended. Circle was not a manifesto in the sense that contributors were asked to support a particular point of view or some written document with which they all agreed. They came from a number of different countries: they had their own very definite ideas about what they were doing (Mondrian for instance would certainly have called himself a neo-plasticist): there were considerable differences of background and without doubt of religious or political points of view.

There was therefore, no attempt on the part of the editors to circulate any statement. Nicholson, Gabo and I agreed quite simply that amongst the many forms of painting and sculpture that were being produced at that time, there were certain works which were not purely decorative, nor were they examples of realism or sur-realism. The descriptive terms applied to this kind of work, for instance 'abstract' or 'non-representational' seemed to us to be inadequate and to remove the idea of content. We believed that such works were positive and affirmative: they were symbols built up around the attempt to construct the work of art, in whatever material, into some sense of wholeness and coherence of form. This type of art represented, as we said in our editorial, work which 'appeared to have a common idea and a common spirit, the constructive trend in the art of our day'. We considered that it was important to demonstrate this attitude of mind by showing examples of this kind of painting and sculpture side by side and we extended the idea by illustrating a range of architectural solutions to varying problems, again selected from the work of individuals in various countries.

The written material was supplementary. Some articles had already appeared and were reprinted, others were specially written, each author being free to write a short note about the subject that they found interesting. Articles like Karl Honzig's 'Note on Biotechnics' which emphasised a parallel between technical structure and natural forms or Siegfried Giedion's 'Construction and Aesthetics' which discussed the work of the brilliant Swiss engineer Maillart were deliberately included to broaden the range of possible discussion.

Above all else Circle was I think an attempt, in a period of considerable confusion, to achieve a clarification and to demonstrate by illustration, examples of a particular attitude of mind that seemed to be valid and at work in the art and architecture that we saw around us. It spoke for its time — or rather for a particular set of ideas that seemed to us to be relevant then. And it is for this reason that when Circle was reprinted thirty four years after its original publication in 1937 we, the editors, felt that it should remain a facsimile without any attempt on our part to re-edit or to add a second introduction.

That is not to say that the individual artists ceased to develop and elaborate their work. Gabo himself during his lifetime broadened his range from objects in perspex and transparent constructions to stone carvings in which the problems of defining space and volume were always central and were no less constructive art in his own terms. Nicholson, throughout his considerable output since 1937, has consistently elaborated the complexity of his work but has always from time to time reflected again in a new form the serene work that we illustrated in the middle thirties. For many of those artists and architects who were able to continue their work, and not all of them did, there is no doubt that the work illustrated in Circle was at least some kind of a base for further development.

I can illustrate the point more clearly and perhaps speak with a little more authority in terms of architecture. The work illustrated includes buildings from Finland, Holland, France, Switzerland, the USA and England. It does not take much insight to see, even at this early date, some special characteristics in the work from Holland or Finland, or some quite distinct differences of interest and emphasis. With the benefit of hindsight we can recognise the beginnings of a series of lines of thought that have since been continuously elaborated and widened. In retrospect we now know how Aalto's work rooted itself more and more deeply in those influences of landscape and materials that came directly from his own background and his own country. At another extreme we can see in Richard Neutra's work within industrialised technology the beginnings of an interest that has today transformed high technology into a poetic expression. Each succeeding generation has widened the range and added a new and a deeper contribution.

And perhaps the whole process is already indicated at least in Marcel Breuer's article on 'Architecture and Material'. He described the new materials and new processes by which buildings and furniture could be produced. He illustrated the effects of this in his own early development of tubular tables and chairs. He shows the development of technique and of form in his aluminium chaise-longue. He illustrates the change of form that results when an old material (wood) is given a new application in bent-plywood. And finally, he illustrates a small exhibition pavilion built almost entirely from traditional materials. It is, as he says, not the new materials that matter but the new mentality which will use the materials that are most appropriate for the task and will produce the new content and the new form.

9

I am glad that some of the paintings and sculpture that we illustrated have now become the classics of their time. It is of some satisfaction also to know that Aalto's Paimio Sanatorium and several other buildings still seem to have a validity and that his housing is cared for by its occupants and, as he would have wished, is now garlanded with climbing plants. Some of Breuer's furniture is so lasting in its use and appeal that (like the remarkable bent-wood furniture of Thonet before him) it is still being reproduced today. So too is the furniture of Alvar Aalto.

On the other hand I am equally glad that some of the work that we illustrated in 1937 at such an early stage has been widely developed and elaborated into new and appropriate forms by each new generation and with a richness that we could not possibly have envisaged. What has remained for me and others of my generation, is a confirmation of the belief that art, whether it is painting, sculpture or architecture can be one of the great constructive and unifying forces in our lives. That is what we intended *Circle* to express.

Circle : the theory and patronage of constructive art in the thirties Jane Beckett

Circle was published in 1937 by Faber and Faber. Although planned some months earlier, publication seems to have been delayed to coincide with the exhibition Constructive Art held at the London Gallery in July 1937. The book and the exhibition, which consisted of work by some Circle contributors, were undoubtedly intended to present a consistent theory and practice within English culture. Yet Circle was a curious hybrid, which drew together the small disparate group of abstract painters and sculptors in England to form an alliance with some of the European artists and architects living in exile in London at that time. Many of these had worked in Germany and Russia as well as in Paris and therefore developed geometric abstract painting in England into a quite different form from that which was familiar to British artists through their contacts with Paris and such French art reviews as Cahiers d'Art. The emigré artists also elaborated a diverse range of theories of art and architecture.

The contents of Circle were assembled by the editors J L Martin, Ben Nicholson and N Gabo deliberately from within the ranks of English abstract painters from a nucleus of artists who lived and worked in close proximity in Hampstead and, more arbitrarily, through a letter of invitation to an international selection of artists, architects, scientists and critics who, they felt, '. . . were working in the same direction and for the same ideas . . .' (editorial page v) Thus, the range of material published in the book of articles and reproductions takes up a particular stance within English culture as well as in an international context interpreted by domiciles and exiles. The contents of Circle are structured into four sections: I Painting, II Sculpture, III Architecture, IV Art and life, implicitly articulating the opening and typographically separate article by Naum Gabo 'The Constructive Idea in Art'. The rigorous structure of the book disguises the diverse range of articles and reproductions, acknowledged in the editorial: '. . . the range of contributors represented here is a large one.' Yet the publication is intended to be partial:
'We have, however, tried to give this publication a certain direction by emphasising, not so much the personalities of the artists as their work, and especially those works which appear to have one common idea and one common spirit: the constructive trend in art of our day.' (editorial page vi)

The force of this polemical editorial, while not strictly a manifesto, nevertheless proposes Circle/constructive art as an internationally unified ideology; the contents of the book reinforce this interpretation.

But what constituted the 'constructive trend'? How far can it be claimed to provide a set of principles that unite the group within Circle? Or rather did Circle bring together, as its editorial claimed, a wide range of contributors with 'no intention of creating a particular group circumscribed by the limitations of personal manifestos'? That simple claim is self-evidently true; unlike earlier European modernist publications, Circle did not contain manifestos. But modernist publications had radically changed during the thirties and polemical and programatic statements were either eliminated or reduced in favour of direct reproductions of works and simple statements by contributors. Examples of this occurred in the journal of Abstraction-Création (1932—1936) and in the review Plastique (1927—1929). Unlike these journals, Circle was programatic and ambitious in content and format. It was a large book, not a modest, little magazine and it intended, as the editorial makes clear, to show that the ideas inherent in its contents were not the temporary mood of an artistic sect, '. . . but on the contrary an essential part of the cultural development of our time'. Moreover 'by placing this work side by side we hope to make clear a common basis and to demonstrate, not only the relationship of one work to the other, but of this form of art to the whole social order'. (editorial v—vi)

What was the relationship of Circle to the cultural developments of the late thirties in England? Did its contents reflect a common body of practice, or theory and how did this relate to the social order?

The late thirties was a period of radical change in English culture and society, brought about by a complex interaction of political and economic forces. This had repercussions on policies concerning housing, education, industry and social issues. It also affected the institutions of the art market — dealers, exhibiting societies, critical approaches — and the social organisation of art production.

In relating these developments to Circle and in seeking to distinguish principles or practices which unify the group, there is a danger that superficial and reduced formulations will result. One of the main difficulties in dealing with cultural groups is to identify a body of practice or a common set of aims, not necessarily articulated in a manifesto, that does not over-simplify and distort the historical conditions in which the group operated.

The 1935 General Election returned a National Government under Stanley Baldwin.[1] An analysis of the voting figures reveals the polarities existing in English society, in which unemployment fluctuated between 1,400,000 and 3,000,000, whilst paradoxically, the real national income continued to rise. This was also reflected in an unequal distribution of wealth and income which had important implications for art patronage. Undoubtedly, the economic

conditions presented real hardship and a threat to professional artists. In the 1931 census, 10,000 people styled themselves 'artists', but only 700 claimed to support themselves solely from their work. Unfortunately this category on the census form allows only a vague interpretation of these figures. Similarly the fact that there was no census in 1941 means that it is not possible to gain a coherent view of the economic pressures on artists in that decade. In the notices section of *The Studio* in February 1934, Douglas Goldring claimed that the depression had one positive aspect for the arts:

'One of the good results of the prevalent depression, which has hit the art dealers as severely as other "luxury" trades, has been to bring into the field a large and wholly new type of picture buyer. The number of wealthy "patrons" who can still afford to pay £500 and upwards for the work of a contemporary artist is, alas, considerably diminished. On the other hand, now that the younger painters, and even some of the older men with established reputations, are contenting themselves with modest prices for their work, the vast army of middle-class flat-dwellers who formerly only aspired to reproductions are beginning to purchase originals'.[2]

This indicates not only a changing structure of dealing and patronage but the further effects of the economic condition on artists' prices. The new practice of purchasing paintings rather than prints that Goldring notes must have had repercussions on the production of art in both areas. The connoisseurs' market for highly romanticised topographical prints which expanded in the twenties, totally collapsed in the thirties. Nevertheless, many artists continued to work with print techniques. For example, unlimited editions of lithographs by twenty five artists were produced with some success between 1936 and 1938 by the Curwen Press under the direction of John Piper and Robert Wellington.

Two recurrent and interconnected themes we find in *The Studio* between 1934 and 1938 are the notion of 'pictures as desirable additions to the modern home' and the implications this had for patronage. The former issue even invades some critical discourses. For instance, in a review of an exhibition at the R B A Goldring rejects Nevinson's *Ave homo sapiens* (present whereabouts unknown) as unsuitable for a private sitting room: 'It would, as auctioneers say, "suit" some provincial gallery.'[3]

The second issue is taken up in the September 1934 issue of *The Studio* which was devoted to conditions of patronage with articles by collectors, dealers and critics. The editors reveal some confusion in the arguments they propose for collecting works of art:

'This issue of *The Studio* is largely devoted to articles on the use of pictures. We say "use" because pictures are undoubtedly *useful*. They serve no material purpose, but they are one of the essential pleasures of intelligence.'

The contradiction implicit in this statement is apparently clarified when the editor suggests that the functional aesthetic of modern architecture with bare walls has brought about a collapse of the art market. In an effort to remedy this ill effect the editorial asserts that art *is* a necessary adjunct to the home as 'food for the mind' and not an expensive luxury. However, the editor acknowledges the implications of investment in works of art:

'Another disturbing factor to many people was the great upheaval of values. The pictures they had once liked, depreciated. New and controversial forms of painting soared (and fluctuated) in price. Security of investment and certainty of merit seemed alike difficult to find.'[4]

But then the reassuring familiar argument returns: 'It is possible to acquire good pictures at a price not-at-all out of proportion to the sum usually allotted for furnishing a house or apartment.' Notions of usefulness, financial value and aesthetic pleasure appear to overlap.

The other articles in this issue either present the 'value for money' argument or a dealer's advice on the purchase of works of art. Derek Patmore suggests in his article entitled 'What people collect' that,

'In so many rooms, one good picture will create interest in an otherwise commonplace scheme of decoration, and I feel that this is one of the many reasons why today people in all walks of life are taking a deeper interest in art, and are beginning to form small collections of their own.'

During the thirties the connection between pictures and interior decoration and furnishing was intensified and became entangled with the broader debate involving design and industry. In 1936 the firm of Duncan Miller held an exhibition called 'Modern pictures in modern rooms' which was designed to illustrate how close was the alliance of abstract art to contemporary architecture and interior decoration. This exhibition, (included in the final section of *Circle*) introduced the work of Piet Mondrian, Jean Hélion and Alexander Calder in London. It also included paintings by John Piper, Ben Nicholson, Arthur Jackson, S John Woods, Joan Miró and Moholy-Nagy and sculpture by Henry Moore, Barbara Hepworth, Alberto Giacometti and Eileen Holding. S John Woods in a highly partisan review in *The Studio*[5] argues tautologically that 'the relationship between contemporary art and architecture exists simply because they are contemporary and therefore they are of interest to all those concerned with contemporary living.' It is not clear how this exhibition was selected but it was

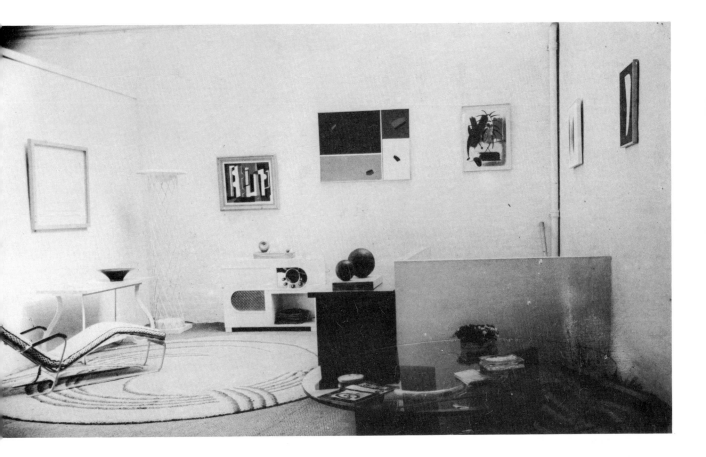

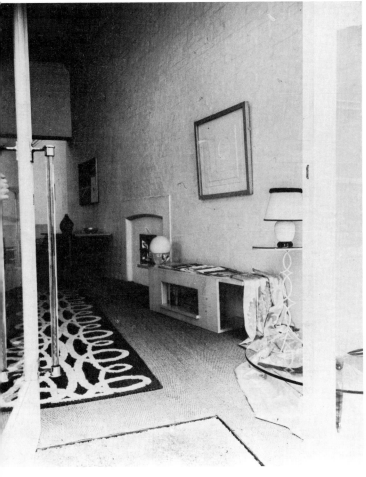

'Modern Pictures in modern rooms' (Duncan Miller
exhibition 1936)

structured in 'rooms' to display furnishings and paintings. Mondrian's work was also introduced in the spring of 1936 in an exhibition entitled, 'Abstract & Concrete' which toured provincial cities before arriving at the Alex. Reid and Lefevre in London.

The 'Modern pictures in modern rooms' exhibition was in marked contrast to an exhibition called 'The Working Class Home' held a year later (1937) at the Building Centre. This exhibition was intimately connected with a complex debate that had economic, industrial, political and aesthetic implications. The development of new industries between the wars, principally in car manufacture, and the development of electricity brought with them new forms of employment, relatively good wages and some social mobility. Political pressures for slum clearances and the development of suburban housing, both public and private in patronage, produced architectural debate on the nature of housing and on its formal and social implications as well as on the design of its fittings. The development and marketing of electricity particularly, introduced a range of fittings for cooking and heating that revolutionised social behaviour; cooking without coal, for example, or the moveable electric fire which meant heat in every room, not just in the living room or parlour.

The form of these new commodities (irons, hairdriers, refrigerators, cookers, fires etc) became a subject of fierce debate which attracted Royal interest in November 1933 at the annual dinner of the Royal Society of Arts, when the Prince of Wales pleaded for 'closer co-operation between manufacturers and artists as essential to successful marketing of British products'.[6] This speech, widely discussed in professional journals and daily newspapers, urged industry to take up the designs of artists and to adopt their ideas 'as to how modern manufacture and machinery can best influence and please the consumer as to taste, convenience and attractiveness'. The speech also contains a tacit acceptance that British design lagged behind its foreign counterpart. 'Young artists,' the Prince urged, 'should go abroad and study the demand which this machine age has evolved in foreign countries as regards tastes, fashion, design, convenience, practicability, etc. Having studied these characteristics, they should then settle down and produce ideas combining the best details which they have discovered abroad with what, for want of a better term, I will call a "new British Art in Industry" '

This discussion intervened in the growing debate on the relationship between the artist/designer and industry that involved the economics of industrial technology and led to the development of numerous societies, publications and exhibitions committed to exploring and exploiting the relationship between architecture, design and industrial production. The response from architectural and design institutions to one such publication, *Official Reports on Housing*, was the sponsorship of competitions and exhibitions such as 'British industrial art in relation to the home', held at Dorland Hall in 1933, and 'New homes for old' held at Olympia in 1934, the same year in which the Council for Art and Industry was set up by the Board of Trade.[7] Furnishing stores also participated by giving exhibition status to furnishing displays such as 'Modern living' held at Whiteleys of Bayswater, London in 1934. The marketing of modern painting was caught up in this movement for two reasons: British artists and architects had become increasingly involved in the ideologies of European modern movements in which the unification of the arts was a cardinal principle; and the pressures of the economic climate led to their involvement in textile and poster design.

One further element in this complex situation was forcibly brought into the forum of public debate by Herbert Read in a review of Niklaus Pevsner's book *An enquiry into industrial art in England* published in June 1937 (see document p 71); the need for a suitable training for the designer and for the education of the manufacturer and the public in its taste. This is an interesting issue, particularly so here, because Read's interpretation of the concept of taste was determined by his involvement with the idealism of modernism. He devoted one whole chapter to a discussion of art education in his book *Art and industry* (Faber and Faber 1934). Read's argument was undoubtedly given force by the experiences of Walter Gropius, László Moholy-Nagy and Marcel Breuer at the Bauhaus and in German and Swiss industry.[8] Indeed, *Art and Industry* quotes extensively from a lecture given by Gropius to the Design and Industries Association[9] on the educational and social premises of the Bauhaus. The inclusion of an Art and Life section in *Circle*, in which these discussions are amplified further, is an attempt to explore a complex and divergent aspect of British culture in the late thirties, but it does little more than map it out superficially. More research must be done before concrete or quantifiable connections can be made between industry and patronage of the arts, or before the full implications of the arguments for the training and education of designers can be understood. Basic questions must be asked such as how commissions were received; how much artists as distinct from designers were paid for their work. Further, what kind of companies employed artists? We know, for example, that Morton Sundour Fabrics Limited, under the chairmanship of Alastair Morton commissioned designs from Ben Nicholson and Barbara Hepworth and that Paul Nash designed tableware for E Brain and Co, but little more

is known of these commissions beyond the actual designs.

There is considerably more information relating to private patronage however. Derek Patmore's article in *The Studio*, referred to earlier, presents an interesting spectrum of patronage of modern painting. The collectors he singles out — Edward Marsh, Lady Jowitt, Hugh Walpole, The Duchess of Roxburgh, Charles Laughton and the Hon Gerald Chichester — were probably not regular readers of *The Studio*. The main readership must have been composed of those engaged in the production of art and design as well as dealers and critics. Evidence of the involvement of the art market is provided by the sort of advertisements carried by the journal. Nevertheless, *The Studio* undoubtedly had a middleclass readership, which to a certain extent determined editorial policy, for it was necessary for the magazine to remain within the field of interest of its readers and to excite their aspirations. Patmore's selection of collectors embraces both these conditions. Charles Laughton and Marie Ney were both actors while Edward Marsh had a highly successful public and political career which culminated in a knighthood.[10] Marsh's collection, built up between 1911 and the 1940s, like that of other collectors in Patmore's article, reflected the dominance of a taste for French painting within certain sections of the British society. In 1937 Mary Chamot commented on the dominant amount of critical attention paid to French painting: 'Most books on modern art deal mainly with the French School, either omitting English painting altogether or only mentioning a few artists accidentally'.[11] Clearly there are subtle inflections and variations in attitude towards French painting in English culture in the thirties. If the prevailing view was based on the Post-Impressionism of those artists associated with Bloomsbury, modified by French 'discipline and a respect for formal organisation', a further change in tone can be discerned in much of the critical writing which appeared after the death of Roger Fry in 1934, and in Clive Bell's support for more conservative forms of modern painting. In 1935 he predicted that
'the next phase of English painting — indeed it is already present — will be the exploitation of the national heritage by artists whose sensibility has been tempered by the discipline of Cézanne and the abstract painters'.[12]

The range of taste in the thirties encompassed the traditional, almost 'official' art of the Royal Academy, the modern collection at the National Gallery of British Art (which became the Tate Gallery and to which Frank Stoop bequeathed his collection in 1933) and the art displayed in the small commercial galleries in London. The distinction between all these kinds of galleries was acknowledged. 'There is room for such an official body [The Royal Academy] to carry on the social business and leave the "pure" artist free to do his work.'[13] However, as Charles Harrison has pointed out in his discussion of the development of English modernism, it was through the critical writings and the priorities with which dealers and collectors made their selections that the mechanism of English involvement in European modernism began to operate.[14]

The symbiotic relationship between critics and commercial galleries caused a fundamental redirection of interest in modern painting in England during the early thirties. 'Freddy Mayor and Douglas Cooper had opened a new gallery in Cork Street in 1933. The first exhibition included Braque, Picasso, Miró, Masson, Léger, Valmier, Herbin, Wadsworth, Bacon, Klee, Arp, Zadkine, Moore and Calder.'[15]

It was at the Mayor Gallery, the Zwemmer Gallery, Alex. Reid and Lefevre and the London Gallery that contemporary European painting was shown in England. The Zwemmer Gallery exhibited work by Picasso, Miró and Calder and held the final show of the Seven and Five Society. The Society had been formed in 1919 from the bland grouping of seven painters and five sculptors, although, in fact, eighteen artists exhibited in the final show. However, during the twenties and until its final show in October 1935 the Seven and Five provided an exhibiting arena for young artists quite distinct from the older Post-Impressionist dominated London Group. Moreover at meetings there was considerable discussion of contemporary painting in Paris and Germany. The work of abstract artists such as Piet Mondrian, Jean Hélion, Hans Arp, Sophie Taeuber, Alexander Calder and Alberto Giacometti was talked about and analysed and thus the hegemony of the Bloomsbury aesthetic rooted in the work of Gauguin, Van Gogh, Cézanne and early Cubism was displaced in both discussion and practice. In their canvases from the twenties both Ben Nicholson and Ivon Hitchens introduced the shallow pictorial space and overlapping planes of synthetic cubism and geometric abstract painting. These were exhibited both in one man shows and at the Seven and Five Society. After Nicholson became chairman of the Society in 1926 the group became more determinedly modern and international in outlook. In the main this meant the withdrawal of those artists whose work was rooted in English naturalism and the landscape tradition. In spite of this, there was a sharp division between those artists who remained and the work of Nicholson, Moore and Hepworth.

In the final show in 1935 Nicholson exhibited an austere white relief, Hepworth the *Discs in echelon* (Museum of Modern Art, New York) and Moore the *Four piece*

composition: reclining figure (Tate Gallery, London). The diversity of interests behind these three works reveals how loosely the connection lay between the artists of the Seven and Five. The geometric abstract forms of Nicholson's reliefs, and his use of an even white in painting them distinctly separates his work from the crafted carvings of Hepworth and Moore which reflect an interest in Brancusi and Arp, particularly the latter in the playful juxtaposition of abstracted forms. Moreover, the psychological activity of the cut-off forms in Four piece composition: reclining figure, and the allusive imagery reveal Moore's debt to the early work of Giacometti.

The inclusion in the final Seven and Five Society show of J C Stephenson, John Piper, Arthur Jackson and Francis Butterfield suggested a strength in depth of a group of abstract artists in England. Indeed in his notice of the show in Axis (no 4, November 1935, pp 21 – 22), J M Richards claimed, 'that we can now be said to possess a school of abstract artists'. While there may not have been sufficient commitment to make this claim, nevertheless the last Seven and Five exhibition reflected the involvement of British artists in abstract painting. The early thirties established new modes of abstract painting in England in which the formation of Unit One in 1933,[16] the establishment of Myfanwy Evans' review Axis from January 1935 to early winter 1937, the critical writings of Adrian Stokes, Herbert Read, John Summerson and Paul Nash and the reviews policy of The Listener played an important part.

Moreover, the active involvement of British artists in avant-garde reviews and exhibitions in Paris realigned British abstract painting with that city by introducing new critical strategies in English art criticism.

Unit One, as Herbert Read's introduction makes clear, had a double intention to present a unified group committed to abstract art and to act as a shop window for the contributors' work.[17] By January 1935 when the first of the eight numbers of Axis appeared, discussion of abstract painting had reached the point where both Myfanwy Evans in her opening article, 'Dead or alive', and Herbert Read in 'Our terminology' (see document p 53) felt it necessary to examine the parameters of the use of the term 'abstract'. Read justified his use of 'abstract' in preference to Hélion's proffered 'concrete' on the grounds of Plato's notion that 'abstract has a cousinship with the term "absolute" and [that] both terms suggest a surplus of intellectual values which exist in abstract painting'.[18] A year later in 1936 Nicolette Gray chose both terms 'Abstract & Concrete' as the title for an exhibition which included work by artists working in Paris: Calder, Domela, Gabo, Giacometti, Hélion, Kandinsky, Miró and Mondrian together with

English abstract artists Hepworth, Holding, Jackson, Moore, Nicholson and Piper. The fifth issue of Axis dealt with the exhibition, reproducing work by the exhibiting artists and articles on the use of the term 'abstract'. Both Axis and 'Abstract & Concrete' explicitly linked British abstract artists with those practising in Paris. The slender economic basis of these enterprises was largely strengthened by the galleries which in turn supported the abstract painters. 'Bookshops were not enthusiastic and three or four copies grudgingly taken on sale or return would often come back, not battered, but dirty. Cambridge bookshops were more helpful than Oxford ones – scientists (Cambridge was still then the Scientific university) were on the whole far more interested in modern art than philosophy or literary dons'.[19] The inclusion of Parisian artists in so many English ventures – for example, Axis, 'Modern pictures in modern rooms' (Duncan Miller 1936),[20] 'Abstract & Concrete' – undoubtedly grew out of the increasing participation in the early thirties of British artists in Parisian activities. Hepworth's, Moore's and Nicholson's work appeared in the journal of the Abstraction-Création, Art non Figuratif,[21] the mouthpiece of a loose alliance of abstract artists working in Paris between 1932 and 1936, through the agency of Jean Hélion. It was Hélion also who encouraged Myfanwy Evans to 'go back and start a magazine of abstract art comparable to Abstraction-Création'[22] This intervention was crucial in redirecting a branch of English abstract painting into a relationship with European modernism. Nicholson's work reproduced in Abstraction-Création no 2 reveals how closely he was still involved in Cubism. This distinguished him from other Abstraction-Création participants, in particular César Domela, Jean Gorin and Bucheister who belonged to a second generation of abstract painters for whom one of the main modes was the geometric abstract relief. Following his involvement with Abstraction-Création Nicholson settled in London in a community of sculptors, designers and architects in Hampstead, which Herbert Read subsequently described as 'A nest of gentle artists'.[23] Into this community, which remained settled between 1932 and 1939, the European exiles were absorbed. Walter Gropius, Marcel Breuer and Eric Mendelsohn lived from 1934 in the Lawn Road flats commissioned by Jack Pritchard from Wells Coates. László Moholy-Nagy and Naum Gabo also came there in 1935 and 1936 respectively and Piet Mondrian lived in a studio in Parkhill Road, next to the Mall studios inhabited by Moore, Nicholson, Hepworth, Stephenson, Ashley Havinden and Herbert Read.

Nicolette Gray's exhibition 'Abstract & Concrete' (held in Oxford, Cambridge, Liverpool and Alex. Reid and Lefevre in London) together with the review Axis provided the public

arena for the activities of British abstract artists and brought them together with the European movement. Clearly there were contradictions within this grouping, in terms of the types of abstract painting, in terms of ideological commitment and in terms of the articulation of the words 'abstract' and 'concrete'. For Herbert Read writing in *The Listener* in October 1935, the concept of abstraction in its most basic sense implied the renunciation of 'any intention of reproducing in any degree *the natural appearances of phenomena*'.[24] He continued the discussion by suggesting that the abstract artist, although not concerned with the external appearance of nature, is interested in 'the principles of life' by which it is animated. Two years later, at a time when Read was involved in Surrealism, he wrote an article in *Circle* entitled 'The Faculty of abstraction'. Read argues along Hegelian lines that art, whether abstract or surrealist, is a perceptual activity. The surrealist explores the unconscious method of reasoning to discover latent perceptions. His task is to give material form to the unconscious activity. The method of the abstract artist, Read claims, is more 'direct'. His aim is 'to construct a plastic object appealing immediately to the senses . . . which shall nevertheless be the plastic equivalent of the senses'. Thus he will resolve the Hegalian dialectical opposition of art and idea by 'creating the synthesis' of abstract concept and affective experience in perceptual form. (*Circle* pp 64 – 65).

The inclusion of exhibition reviews in *The Listener* and of discussion of abstract painting, particularly between 1933 and 1939, indicates how much this debate was taken up within English culture. *The Listener* had been founded as a 'vehicle of general culture' with a secondary educational role.[25] Its ambiguous cultural stance in the thirties is clear from the controversy which surrounded its initial publication in 1929; its opponents claimed that it would necessarily be interpreted as official and authoritative — the written word in *The Listener* being the equivalent to the voice of the British Broadcasting Corporation. The literary editor of *The Listener* from the mid-thirties, J R Ackerley, was generally acknowledged as a vigorous editor who 'forced the pace with his adventurous choice of writers and subjects'. Together with abstraction the discussion of Realism was also embraced by all sections of British culture. It was debated in *The Left Review* (1934 – 38) by The Artists International Association (founded in 1933) and was presented in *The Listener* by Herbert Read in an article on Soviet and Nazi realism.[26] Echoes of this debate occur in Le Corbusier's article 'The quarrel with realism' and Ben Nicholson's 'quotation' in *Circle*. It was in terms of a broadly based political and social commitment, as well as of an Internationalist stance, that connections between the A I A

and *Circle* existed. Abstract painters participated in the 1935 exhibition 'Artists against war and fascism', and in the 1937 A I A exhibition in which there was an abstract section. General views of this latter were reproduced in the back of *Circle*. However, the commitment to quite different forms of painting is clear from the critical support of left wing critics and writers on the side of 'realist' painting. For example, Anthony Blunt, writing in *The Left Review* establishes the lineage of realism: 'The line of Daumier, Courbet, the early Van Gogh, Meunier and Dalou is that of the real art of the growing proletariat, while that of the bourgeoisie continues the abstraction of the twentieth century'. Moreover, 'If we mean by revolutionary art the art which most closely represents the ideas of the rising class, there can be no doubt that the true revolutionary art of today will be realistic'.[28] The role of the artist, and of revolutionary art within the abstract group was based on quite different principles. The reviewer of the 1935 A I A exhibition points out this distinction in quoting from Herbert Read's contribution to *5 essays on revolutionary art:*[29] 'abstract art . . . keeps inviolate, until such time as society will once more be ready to make use of them, the universal qualities of art — those elements which survive all changes and revolution. I must confess that of the abstract works on show, only the paintings of Moholy-Nagy seemed to me to attempt this function, and to be in an effective sense paintings aiming at an algebra of proportion and design'.[30] In his article 'The constructive idea in art' (*Circle* pp 1 – 10), Naum Gabo argues from the same position, namely that the artist's voice is privileged within society and can intervene and determine the course of culture:

'The Constructive idea sees and values Art only as a creative act. By a creative act it means every material or spiritual work which is destined to stimulate or perfect the substance of material or spiritual life. Thus the creative genius of Mankind obtains the most important and singular place. In the light of the Constructive idea the creative mind of Man has the last and decisive word in the definite construction of the whole of our culture'.(*Circle* p 7)

The precise motives in publishing *Circle* are unclear. Myfanwy Evans' review *Axis* had served as a focus for abstract artists since its inception. However, following the surrealist Exhibition at the New Burlington Galleries in June 1936 it began to include reproductions and discussion of surrealist work. Whether *Circle* was a direct response to Surrealism in a manner comparable to the formation of *Cercle et Carré* and *Abstraction-Création* is also unclear, although it was undoubtedly related to this. Part of an answer must lie in the intervention of artists and architects who had worked in Germany and Paris, such as László

Moholy-Nagy, Naum Gabo, Walter Gropius and Marcel Breuer who brought with them a commitment to an ideology of abstract art rooted in scientific analogies, and as far as the architects were concerned a commitment to a theory of industrial design. Gabo's article on Constructive Art in *The Listener* (see document p 59) makes quite explicit that the word 'constructive' has superceded 'abstract' or 'concrete' and is not to be confused with 'Constructivism', which is a term imposed by critics. Rather the constructive idea is 'based upon new stable principles and new constructive elements'. These principles function in the form of either painting or sculpture or architecture. In his introductory article in *Circle*, Gabo extends this argument to equate Art and Science:

'We can find efficient support for our optimism in these domains of our culture where the revolution has been the most thorough, namely in Science and in Art' (*Circle* p 1) . . . 'Art and Science are two different streams which rise from the same creative source and flow into the same ocean of the common culture, but the currents of these two streams flow in different beds. Science teaches, Art asserts; Science persuades, Art acts.' (*Circle* p 8)

Gabo's comments can be related to important scientific experiments taking place in Cambridge. In 1932, for example, Chadwick established some of the properties of the neutron and Cockroft and Wilton succeeded in disintegrating atoms by bombarding them with protons. Certainly the inclusion of J D Bernal in *Circle* suggests a direct connection with scientific work. (see document p 77) Indeed the works of Gabo and of his brother, Antoine Pevsner, reproduced in *Circle* indicate how closely they worked with scientific metaphors in the use of delicately structured and elegantly ordered relief, three dimensional sculptured forms in plexiglass and highly polished metallic surfaces.

If there can be said to be a common practice among the artists whose work is reproduced in *Circle* it is a concern with a precise geometrically ordered set of forms. However these must be separated into the work of three generations: cubist and cubist inspired work, acknowledged by Gabo in 'The constructive idea in art' as 'the immediate source from which the Constructive idea derives'; the first generation of geometric abstract painters, such as Malevich, Arp, Mondrian, Moholy-Nagy, Lissitsky and Klee, and sculptors, such as Tatlin, Meduniezky, Brancusi and indeed Gabo himself; and finally, the present generation represented by Hepworth, Moore, Calder and Giacometti among the sculptors and Ben Nicholson, Vordemberge-Gildewart, Domela, Jackson, Stephenson, Hélion, Dacre, Erni and Piper among the painters. The position of Piet Mondrian is

extremely interesting. He was visited by many English artists in his studio in the Rue du Départ in Paris, which acted as an inspiration and a model of the possibilities for abstract art.[31] Mondrian's contributory essay, 'Plastic art and pure plastic art' was his first major theoretical work for some years and deals with the figurative and non-figurative polarities present in contemporary art. He argues very strongly for commitment to abstract painting and to the unity of architecture, painting and sculpture within a universal vocabulary with the possible consequence that the complete realisation of unity between the arts will 'in a future perhaps remote' bring about 'the end of *art as a thing separate from our surrounding environment*' (*Circle* p 56). Mondrian's acceptance of the term 'Constructivism' is also curious, and needs further elaboration in connection with his earlier use of 'plasticism' to denote abstract art. However his work is given an important place in the pages of the book, following Malevich and preceeding Nicholson's four sparse geometric reliefs.

To return, then, to the original questions. *Circle* participates in the cultural preoccupations in England during the thirties. The connections established with French artists and with exiled European artists after 1934 distinguished the contents of *Circle* from those of *Axis*, although initially they hold the same ideologies and work within the same forms of art. To distinguish the common factors in the work reproduced in *Circle* — a concern with geometric forms, shallow pictorial space and with the precise construction of these elements — is to blur the differences between the works and thus betray some of the variety and richness. The more ambiguous spatial configurations in the works of Hélion, Erni, Dacre and Piper are in marked contrast with the austere, 'pure' forms of Nicholson and Mondrian. Similar distinctions can be made between the simple geometric forms of Hepworth's sculpture and the complex spatial configurations of Tatlin, Calder and Pevsner.

The dominance of the work by Mondrian, (all recently completed works), Nicholson, Hélion, Hepworth and Gabo suggests a unity within the book that is not actually apparent on closer examination. Quite distinct positions emerge between the different interpretations of the forms of abstract painting. What is not clear either is whether any artists refused the invitation to participate. Some names such as Marlow Moss, G L K Morris and Kurt Schwitters for example, might reasonably have been included. (The same question is raised by Nicholas Bullock in his essay in this catalogue).

Circle presents rather than represents a confluence of different modes of abstract and constructive art within a European modernist ideology that stands in a direct

relationship to 'the whole social order'. This idealist position was fractured within English culture by the time that *Circle* was published. Although Mondrian arrived in England in 1938, presumably encouraged by the publication and the apparent vitality of abstract activity of the last five years, *Circle* was virtually the swansong of English abstract art. An exhibition entitled 'Living art in England', 1939 was dominated by surrealist work, and within a few months, war with Germany was declared and the cultural unity completely broken.

Circle, however, was as Mondrian wrote 'a prachtboek' — a beautiful book.[32]

1 *Voting figures, 1935 General Election:*

Conservative	11,810,158	432 seats	53.7% of votes cast
Liberal	1,422,116	20 seats	6.4% of votes cast
Labour	8,325,491	154 seats	37.9% of votes cast

2 Douglas Goldring. 'Artists and pictures', *The Studio* Vol CVII no 491, February 1934, p 100. Goldring goes on to discuss an exhibition of works for sale at prices not higher than £10, by Eric Gill, Frank Dobson, Charles Ginner, C W F Nevinson and Algernon Talmage.

3 Goldring ibid p 100

4 *The Studio* Vol CVIII no 498, September 1934, p 107

5 *The Studio* Vol CXI no 519, June 1936, pp 331 – 332

6 'The Prince of Wales calls for the recognition of the artist in industry', *The Studio* Vol CVII no 490, January 1934, pp 3 – 4

7 The publication of John Gloag's *Industrial art explained*, London 1934, Herbert Read's *Art and industry*, London 1934, F R S Yorke's *The modern house*, London 1934, and Raymond McGrath's *Twentieth century houses*, London 1934, were products of this interest. The Society of Industrial Artists was founded in 1930.

8 Through the publication in 1935 by Faber and Faber of *The new architecture and the Bauhaus* by Walter Gropius, translated from the German by P Morton Shand.

9 Herbert Read op cit pp 39 – 40

10 Edward Marsh (1872 – 1953) Assistant Private Secretary to H H Asquith 1915 – 16, Trustee of the Tate Gallery 1937 – 44, and Chairman of C A S 1937 – 52. See *An honest patron*, exhibition catalogue published by The Bluecoat Gallery, Liverpool 1979. Also *Frank Dobson*, catalogue to an exhibition published by Kettle's Yard 1981. (cat 69)

11 Mary Chamot *Modern painting in England*, London 1937

12 Clive Bell 'What next in art?' *The Studio* Vol CIX no 505, April 1935, pp 176 – 185

13 Mary Chamot op cit p 80. Chamot presents an interesting chapter on the dominant modes of Royal Academy painting during the thirties.

14 Charles Harrison. Introduction to *Unit 1* catalogue, Portsmouth City Museum and Art Gallery 1978 pp 1 – 3. This receives fuller treatment in his *English art and modernism 1900 – 1939*, London 1981, where he discusses the characteristic modes of painting in the late twenties and the introduction, chiefly through Paul Nash, of European developments.

15 M Piper: 'Back in the Thirties', *Art and Literature* 7, 1965 pp 136 – 150

16 The formation of Unit One was announced in a letter to *The Times* from Paul Nash on 12th June 1933. The group comprised both artists and architects.

17 Herbert Read (Ed) *Unit One: The Modern Movement in English Painting, Sculpture and Architecture*. London 1934

18 Herbert Read: 'Our Terminology'. *Axis 1* Myfanwy Evans (Ed) Jan. 1935, p 7

19 Myfanwy Piper: 'Back in the Thirties', op cit. The economic problems were also recalled in this article: 'Money, even the smallest amounts, were a great nuisance. When Nicolette Gray arranged, with *Axis*, the first English international exhibition of abstract art in 1936, it opened at Oxford. The poet Ruthven Todd (who afterwards settled in the States) somehow got round an uninterested editor to allow him to review it for the *New Statesman*. Not having enough money for the six-shilling fare, he managed to cajole five shillings out of him as well. The last shilling he borrowed from the station master at Paddington. I have a letter from Hélion's wife complaining of the difficulty of finding eight francs to go with forty centimes in her purse for the postage of photographs and an article to New York. I remember Ben Nicholson getting down to his last shilling, and telephoning in triumph to say that he had managed to get one of his faithful collectors to buy a picture for fifty pounds or so, enough to get him and Barbara through the next two or three months. This seemed riches; most people could only raise ten, at the most twenty, in a crisis. (p 146)

20 It is interesting to note that this exhibition is recorded in the back of *Circle* with the title 'Abstract art in contemporary settings', a more restricting and committed title

21 *Abstraction-Création*, no 2 1933 p 9 Nicholson, *Figure* 1932 (Hepworth Estate); p 6 Hepworth *Pierced form* (destroyed) and statement. 22 Dec 1933 'Abstraction-Création' exhibition: included works by Nicholson and Hepworth. *Abstraction-Création*, no 3 1934, p 23 Hepworth, *Figure (mother and child)* coll. T D Jenkins and *Reclining figure*, 1933, Hirshorn Coll. New York; p 35 Nicholson *Six circles*, 1933 (private collection) and *Relief (five circles)* destroyed

22 Statement made in conversation with the author

23 Herbert Read, 'A nest of gentle artists', *Apollo*, Vol LXXVII no 7, September 1962, pp 536 – 542

24 Herbert Read, 'Ben Nicholson and the future of painting', *The Listener*, Vol XIV, no 352, p 604. See document p 62

25 For a detailed discussion of *The Listener* see A Briggs, *The History of Broadcasting in the United Kingdom*, Vol II, *The Golden Age of Wireless*. For the controversy surrounding the foundation of *The Listener* in 1929 see *The Listener* 18 January 1979.

26 *The Listener*, 2 October 1935, p 579

27 For example, Moholy-Nagy lectured to the A I A on 'Why paint today?' in May 1936. For an introduction to the role of the A I A in English culture and society see D D Egbert *Social radicalism and the arts*, London 1970, pp 495 – 550

28 A Blunt 'The realism quarrel' in *The Left Review* Vol III no 3 April 1937, pp 169 – 171

29 *5 essays on revolutionary art*, London 1935

30 Montagu Slater 'Artists International Review 1935', *The Left Review* Vol II no 4 Jan 1936, pp 161 – 166

31 Ben Nicholson in a letter to John Summerson, 'His studio . . . was an astonishing room; very high and narrow . . . with a thin partition between it and a dancing school . . . he'd stuck up on the walls different sized squares painted with primary red, yellow and blue and yellow-and -white and pale grey . . . The feeling in his studio must have been very like the feeling in one of those hermits' caves where lions are supposed to go to have thorns taken out of their paws', quoted in John Summerson *Ben Nicholson*, 1948 p 12. 'Mondrian lived alone in his double cube studio the window high up and the steep staircase that led out of it divided with black lines and sparse rectangles of colour so that it was hard to tell which was wall and which was a painting hanging on it. The sense of scale was exact, and the whole rather sober in intention, but capable of a sudden appearance of gaiety . . .' M Piper, 'Back in the thirties', op cit p 139

32 Letter 30 July 1937 to Mondrian 'I got the English book with my article. It costs about 150 francs — a prachtboek.'

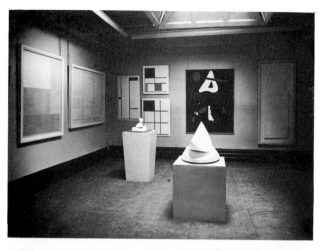

Abstract & Concrete exhibition, London, 1936

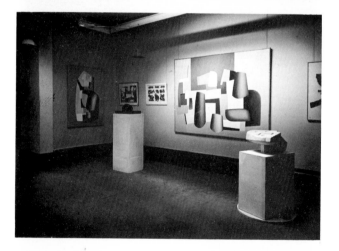

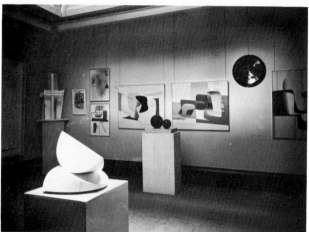

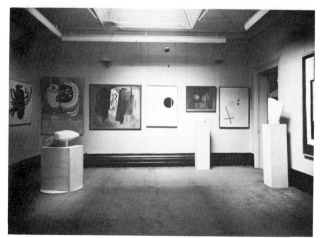

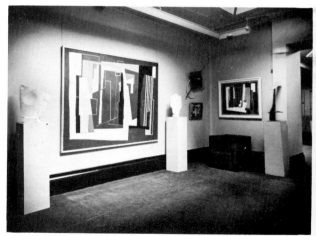

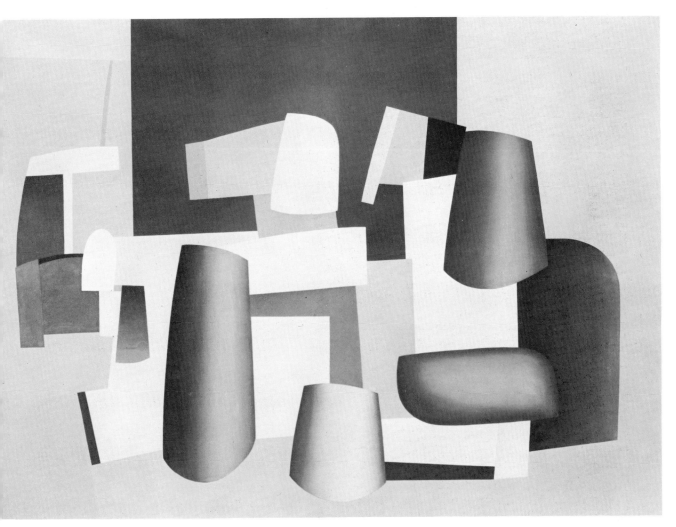

9 Jean Hélion *Ile de France* 1935

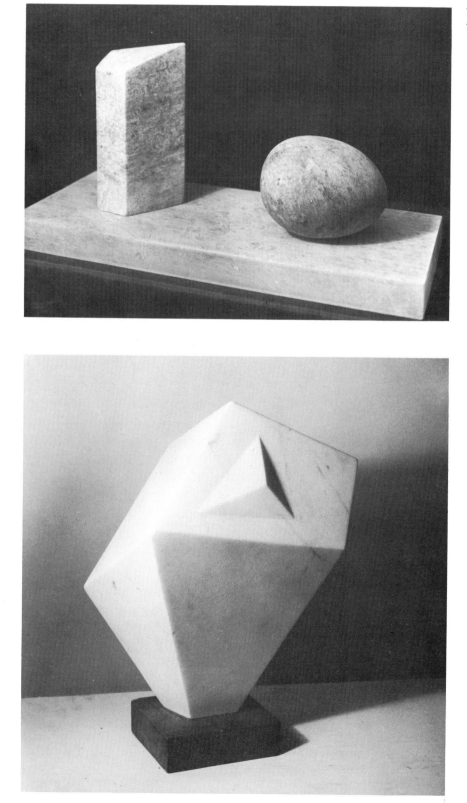

11 Barbara Hepworth *Two forms*
12 Barbara Hepworth *Form* 1936

13 Barbara Hepworth *Single form* 1937

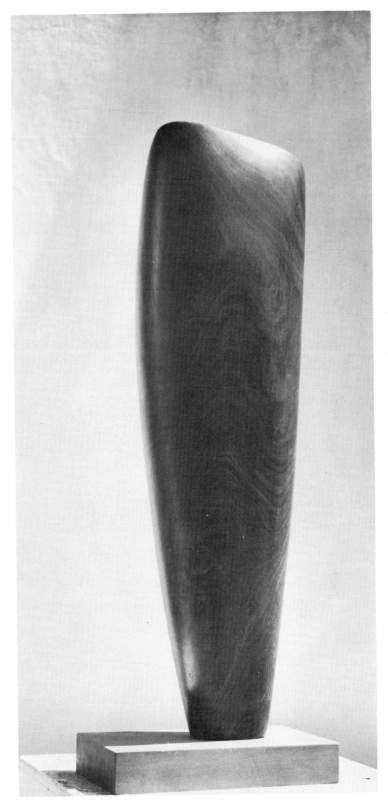

15 Arthur Jackson *Drawing* 1936

19 Kasimir Malevich *Suprematist composition* c.1916

16 Arthur Jackson *Painting* 1937

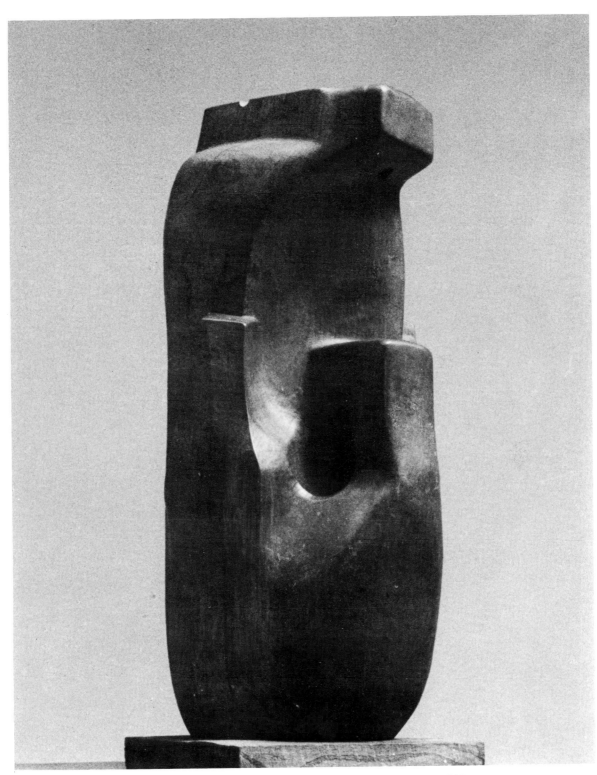

21 Henry Moore Carving 1935

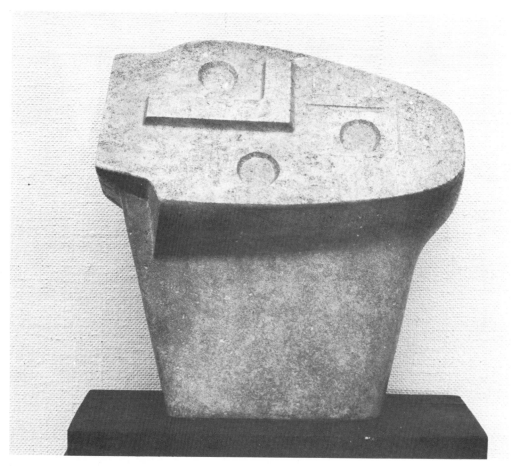

22 Henry Moore Carving 1936

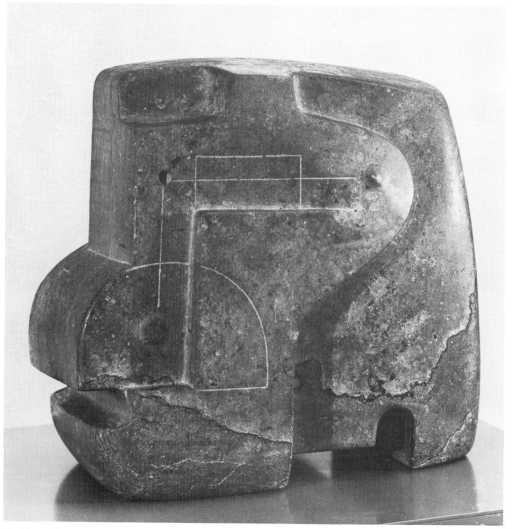

23 Henry Moore *Square form* 1936

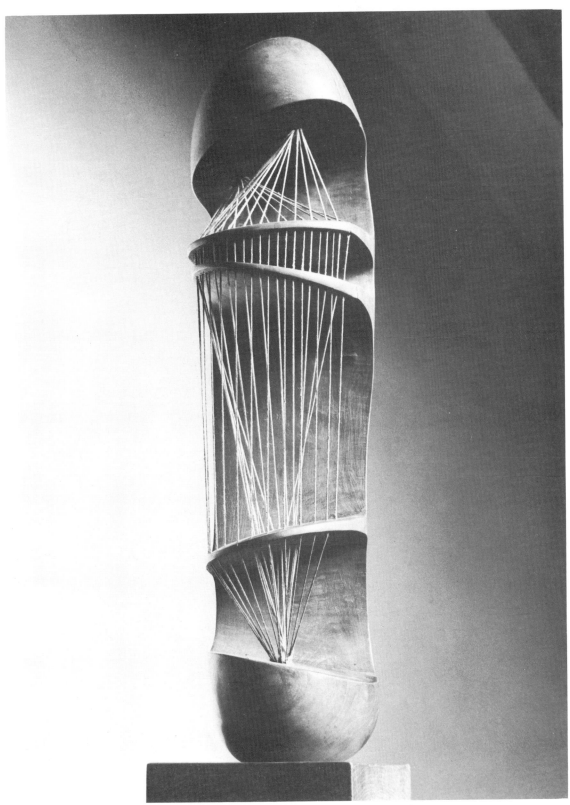

24 Henry Moore *Stringed figure* 1937

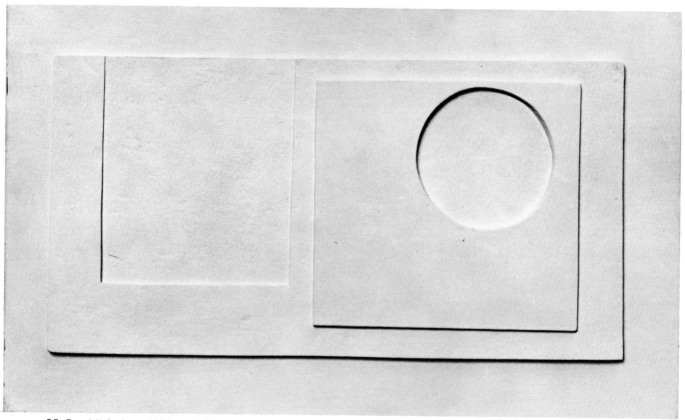

25 Ben Nicholson *White relief* 1934

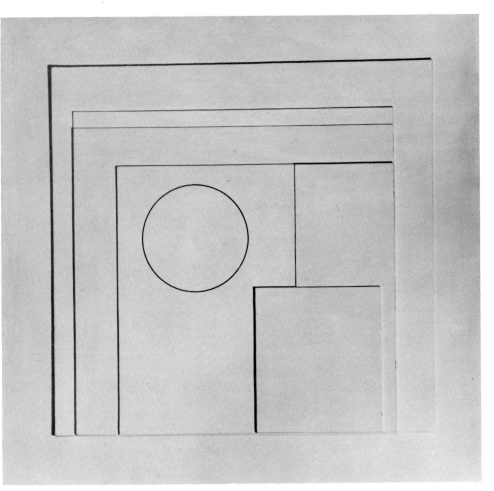

29 Ben Nicholson *White relief* 1939

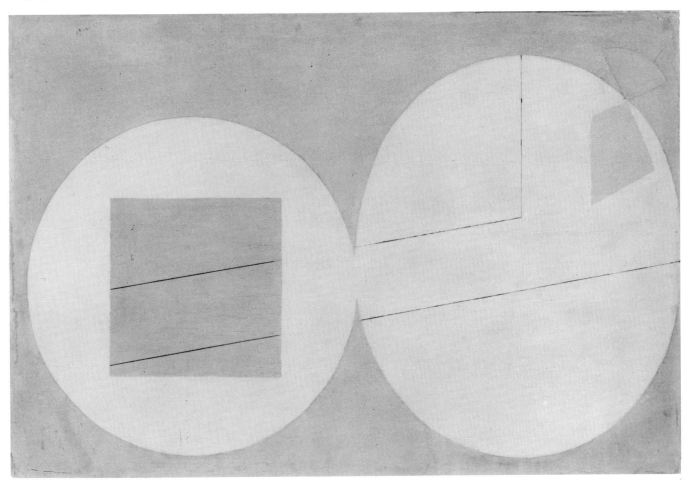

30 Winifred Nicholson *Quarante-huit Quai d'Auteuil* 1935

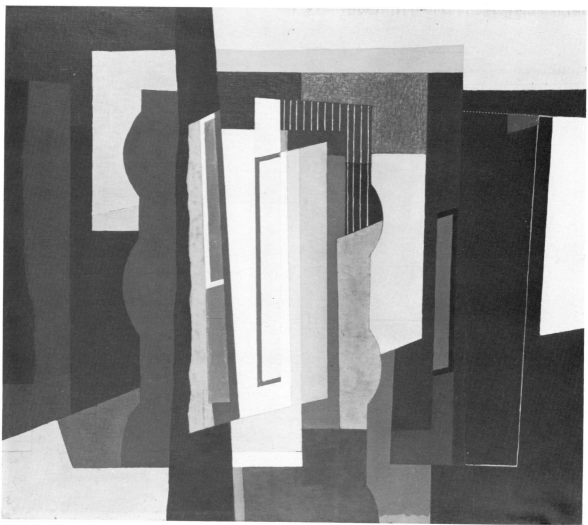

32 John Piper *Abstract 1* 1935

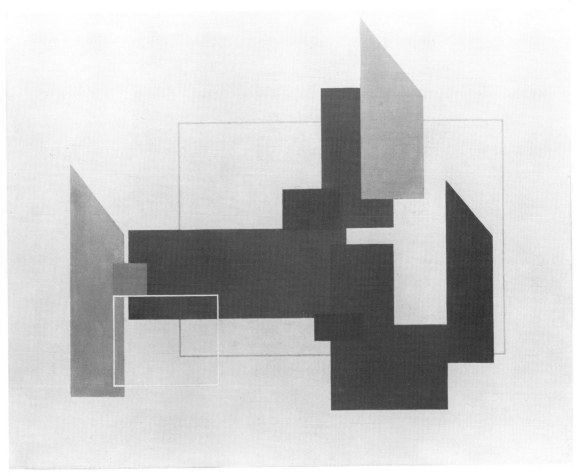

34 John Cecil Stephenson *Painting* 1937

36 Friedrich Vordemberge-Gildewart *Composition no 94* 1935

Circle and the constructive idea in architecture

Nicholas Bullock

The opening page of *Circle* boldly proclaimed: 'A new cultural unity is slowly emerging out of the fundamental changes which are taking place in our present-day civilisation'. This new cultural unity linked the different arts, painting, sculpture and architecture and reached across national boundaries. Like the new science, these new developments in the field of art were emerging spontaneously and advancing in a common direction. This 'organic' growth of the 'constructive idea' across different countries was seen as confirmation of the generality of these ideas and proof that they formed 'an essential part of the cultural development of our time'. In painting and sculpture, the achievements of artists in Germany, France, Holland and Russia could already be matched by English work: Nicholson, Piper, Hepworth and Moore had been working along lines similar to their continental contemporaries for some time. But what of developments in architecture?

As late as 1933, much of the public and even the profession still shared Sir Reginald Blomfield's choleric view of the New Architecture: it is 'essentially continental in its origins and inspiration . . . it claims as a merit that it is cosmopolitan. As an Englishman and proud of my country, I detest and despise cosmopolitanism.'[1] Even by those sympathetic to it, the New Architecture was generally regarded as a product of the French and German avant-garde, and many doubted whether it would ever take root in an English setting. As if in confirmation of these views, many of the first widely publicised ventures in the new style in England were widely regarded as the work of emigrés newly arrived from Europe. Maxwell Fry could be dismissed as no more than the English amanuensis of Gropius; Chermayeff, despite his impeccably English education – at Harrow – was, as his name betrayed, of foreign origins and had served an architectural apprenticeship in Paris; nor can his reputation as an international Tango champion have endeared him to establishment figures like Blomfield. Even the Penguin Pool in Regent's Park, a major triumph in establishing a popular appeal for the New Architecture, was in reality the work of a Russian emigré called Lubetkin. Could the editors of *Circle* plausibly claim that, as in painting and sculpture, there was a genuinely English contribution to the New Architecture? Or were the few modern buildings in England the product of a passing stylistic fad of foreign origin, which would wither as soon as the rootless emigrés hurried through England on their way to America?

To substantiate the claim made by the editors of *Circle* it is not sufficient to rehearse yet again the general development of the New Architecture in Britain. More important, we have to differentiate between the broad front advance of modernism in English architecture and those developments which were regarded as leading to the views represented by *Circle*.

Looking through the architectural contribution to *Circle* it is immediately clear that a variety of views on architecture are included: these range from the freedom of Aalto's interpretation of the New Architecture in rural Finland to the programatic designs of German architects like Gropius and Breuer. With this diversity there could be no question of a manifesto, or a narrow 'party-line'. Nevertheless the unity of approach conveyed by the common allegiance to the 'constructive idea' is still apparent both in the work of the 27 architects whose work was illustrated and in the different articles on architecture and planning.

Central to this broad interpretation of the 'constructive idea' was the belief that the forms of architecture, like the products illustrated in Read's *Art and Industry* (1934) (page 38) should reflect the new age. Convinced of the necessity for art and design to reflect the new age – a view already set out by Mumford in *Technics and Civilisation* (1934) – the editors of *Circle* saw the New Architecture as the appropriate response to the new realities:

'It has now been proved that the only possible departure for artistic creation is modern life, and that life includes *all* contemporary realities. The balancing and controlling counterpart to a contemporary technique is an equally contemporary aesthetic. The aesthetic corresponding to the machine technique is no longer a matter for speculation. The new aesthetic exists in the motor car and the aeroplane, in the steel bridge and the line of electric pylons. Its values, precision, economy, exact finish, are not merely the result of technical limitation. They are the product of artistic selection. The modern architect and the industrial designer, confronted at every point in the technical process with the choice between alternatives, moves instinctively towards simplicity and economy'.[2]

For all the architects whose work appears in *Circle*, the realisation of this potential of the new age was a central preoccupation. The styles of the past, indeed the notion of the individual style, was now dismissed as irrelevant to the present, as were pre-cubist modes of vision, or pre-Einstein physics. The New Architecture was to exploit this new approach to design together with the full promise of the new technology and the new materials, to meet the requirements of the new urban society for housing, for health, for transport and for leisure. The resulting simplicity and economy of their work would rise above style and individualism to restore in the New Architecture the qualities

of design that had flourished in the great periods of the past.

Starting from this position it was natural to differentiate between this 'constructive' approach to design and those who debased the forms of the New Architecture, using them as stylistic motifs to be added or not as whim dictated. For Martin, the Jazz Modern of 'modernistic garages or the moderne dance halls and amusement palaces of our seaside resorts'[3] was anathema. Thus much of the experimentation with the forms of the New Architecture carried out in England during the early 20's must be dismissed as irrelevant to the formation of the ideas defended by Circle. The early designs of Crittal and Quennell at Braintree, the factories built by Wallis Gilbert, the fashionable re-modelling of the Strand Palace Hotel by Oliver P Bernhard, the interiors of the Lyons corner houses, all were trivial stylistic games. The 'Odeon Style', (page 38) interchangeable with the Aztec or the Moorish style at the bidding of a corporate client, could never be confused with the New Architecture which was to be the 'organic' product of the new age.

However, in contrast to this frothy 'juke-box modern', there already existed in England another approach to design which explicitly emphasised the importance of the New Age as a point of departure. Even before the war these ideas had been advanced by men like Lethaby who was both heir to the English arts and crafts tradition and aware of the achievements of the German Werkbund. In Form and Civilisation (1922) he had already set out the case for an approach to design that took account of the changes in society and the impact of the machine, in a way that was consciously modelled on the Werkbund. Despite the continuation of the craft tradition and the absence of any direct involvement in architecture, the Design and Industry Association (DIA), founded in 1915, championed the cause of an approach to design in keeping with the requirements and technology of an industrial age. The importance of these advances for architecture should not be underrated; Lethaby, one of the founding fathers of the Association and highly regarded as an architect, saw a direct connection between art, design and architecture.

One of the stated aims of the DIA was 'to harmonise right design and manufacturing efficiency, accepting the machine in its proper place, as a device to be guided and controlled, not merely boycotted';[4] one of its central tenets was that 'The first necessity of sound design is fitness for use'.[5] Sadly the DIA was not as immediately effective as the German Werkbund in raising the standard of English design. During the 20's membership rose only slowly — by 1918 it was only 602 — as Pevsner's survey, Industrial Art in England (1937), showed contacts between designers and

manufacturing industry took time to develop. By 1927 progress had been made: the association was able to arrange for a selection of English design to be displayed at the Exhibition of Industrial Art in Leipzig where it attracted favourable reports. However, during the early 30's the DIA became more influential. Both through its journal, Design for Today, and through its exhibitions, the DIA did much to establish a greater awareness of the need for new and higher standards of design for industrial production. From 1933 onwards it arranged the construction of a series of exhibition houses in Manchester, Welwyn, and Birmingham to show the general public that good design did not necessarily cost more. The campaign for good design, strongly supported by the BBC, was greatly strengthened by the success in 1933 of the 'Exhibition of British Industrial Art in relation to the Home' at Dorland Hall. The exhibition, backed by a number of organisations including the DIA and Country Life, was laid out and co-ordinated by Oliver Hill, but also contained sections by younger architects like Wells Coates, McGrath and Chermayeff.

While organisations such as the DIA were struggling to improve the quality of British design, the ideas and experiments of continental designers and architects were gradually winning wider recognition in Britain. Again the process was slow. The Paris 'Exposition des Arts Decoratifs' in 1925 did something to open English eyes to European developments in architecture, although the results were not always beneficial. The craze for the angular styling of Art Decoratif inspired by Chareau and Mallet Stevens, and the 'boudoir moderne' style of Süe et Mare encouraged a flashy and superficial modernism that was avidly absorbed. But the effects were not wholly negative: Wells Coates' first impression of the New Architecture was Le Corbusier's Pavillon de l'Esprit Nouveau.

Certainly during the next few years English interest in the work of the continental avant-garde grew rapidly, becoming better informed and more discriminating. The ideas of the leading French and German architects also became more accessible: Etchells' translation of Vers une Architecture appeared in 1927 and there was extensive (and sympathetic) coverage of the Weissenhof Exhibition in Stuttgart by the Architectural Review, The Studio and The Architect and Building News. By 1928 both The Studio and the Architectural Review were carrying regular articles on the New Architecture, a number devoted to the work of Le Corbusier.

One of the most important developments in favour of the New Architecture was the change in the editorial policy of the Architectural Review. At the end of 1927, William Newton (who maintained the historicist interests and neo-

Georgian sympathies of his father who had been editor of the *Review* before him) was replaced by Christian Barman and with this change much of the burden of day-to-day policy was delegated to Hubert de Chronin Hastings. It was he, rather than Barman who was responsible for the new direction and it was Hastings who appears to have been instrumental in introducing new writers like Morton Shand and Raymond McGrath to the *Review*. Shand, with his wide ranging contacts on the continent, did much to direct the interest of the *Review* to events in Europe and to Germany in particular. The *Review* started to illustrate the work of the continental avant-garde, and indeed, by the end of the 20's, it had become the principal champion of the New Architecture in England.

Increasingly conscious of the work of the avant-garde and also the range of different varieties of modernism in Europe, the *Review* adopted a more critical stance to much of what, in England, had passed for modern during the 20's. By 1930, the *Review* was drawing a clear distinction between 'jazz modernists' like Oliver Hill, Grey Warnum or Walmesly Lewis who were condemned as 'old-fashioned craze mongers grabbing at a new brand of Art Nouveau',[6] and the work of the 'truly simple modernists', the leaders of the French and German avant-garde like Le Corbusier and Gropius. Supported by Morton Shand's able advocacy and handsomely illustrated with excellent photographs, the best work of the European avant-garde was given wide coverage. The *Review* reader was now presented with the notion of the New Architecture as the appropriate architecture of the present, a true reflection of the values of an industrial age, using to the full the new technology and the new materials such as concrete, steel and glass.

Equally important for the establishment of a clear identity for the New Architecture in England was the possibility, by 1930, of actually seeing at first-hand work by architects who drew inspiration from the European mainstream. 'High and Over' (page 39), the house built by Amyas Connell for Bernard Ashmole near Amersham during 1929, was the first building in England to realise the ideas of the continental avant-garde and a clear contrast to earlier *moderne* designs such as Tait's 'Le Chateau' at Silver End (page 39). Connell's debt to Paris is clear; his design makes use of ideas drawn from Le Corbusier ('Villa Cook') and Lurcat ('Maison Guggenbuhl'). With its simple bold forms, its concrete frame and white rendered brick work, 'High and Over' signalled a new point of departure. It was soon to be followed by a number of other houses in the same manner. Even before 1934, these included the houses built by the first modern practices, Connell, Ward and Lucas and Tecton, and, here in

Cambridge, George Checkley's White House in Conduit Head (1930–31). The designers of these houses encountered sporadic hostility from the public and the more conservative members of the profession who served on the planning panels brought into being by the Town and Country Planning Act of 1932. But set in the familiar surroundings of the middle-class English suburb, and illustrated in F R S Yorke's *The Modern House* (1934), the houses offered to those prepared to make the effort to find them, a first view of the New Architecture transplanted to an English setting.

This period between 1930 and 1934 marks a period of transition and consolidation. The distinction between *moderne* and *modernistic*, and 'the modern' was now well established; the 'speed-whiskered' factory of the Odeon cinema could no longer be confused with the work of the avant-garde. The coverage of the New Architecture, or Modern Architecture as it was now also called, was extended. Readers of the *Architectural Review* could follow the development of the architectural debate in Germany, through the reporting of Morton Shand, in France, through Etchells; the Stockholm Exhibition of 1930 was well illustrated and showed a refreshing, even light-hearted view of the New Architecture. The *Review* was even offering a critical history of the New Architecture. Anticipating by a few years Pevsner's *Pioneers of Modern Design* (1936), Shand traced the development of the new movement, stressing the importance of the German achievement and of the Werkbund (with its debt to England) in particular. Yet despite these advances in understanding and in practice the English contribution remained muted. So far, England had remained an importer of ideas. English architects were happy to adapt and explore ideas and forms coming from the Continent, but there was still no specific and obviously English contribution to the development of the mainstream of the New Architecture.

By 1934 or 1935, the position had changed; at last in the mid 30's it is possible to recognise the emergence of an English debate. Two developments were of particular importance in bringing this about. First was the arrival in England of a number of architectural emigrés from the continent. One of the first to arrive was Berthold Lubetkin. Trained in Moscow, Berlin and Warsaw, he had worked in Paris (supervising the construction of Melnikov's pavilion for the 1925 Exhibition) and was invited to England in 1931 by a group of Architectural Association students, and together they formed the Tecton group in 1932. He was soon followed by a number of architects from Germany, many of them already well-known in England through publications like the *Review*. Erich Mendelsohn and Eugen Kauffmann

arrived in 1933, Gropius and Goldfinger arrived the year after, and they were followed in 1935 by Breuer. Thus by the mid 30's the architectural debate in England was also able to benefit from the same injection of new ideas from abroad that had done much to spur forward the developments in painting and sculpture. For many of the emigré architects practice presented difficulties; certainly the commissions that architects like Gropius had hoped to find did not materialise. Nevertheless, the arrival of the emigrés in England did usher in new ideas; here at last were men who could present with authority the latest developments on the Continent.

The second development that did much to raise the standard of debate on the New Architecture in Britain was the formation of a number of new groups to champion the new approach to art, architecture and design. Typical of these was the short-lived 'Unit One' founded in October 1933. It brought together artists, sculptors and architects like Moore, Nicholson, Hepworth, Paul Nash, Wells Coates and Colin Lucas (page 40) and provided a valuable point of contact for those arriving in England like Breuer, Gropius and Mendelsohn. In the spring of 1934 the group organised an exhibition in the Mayor Gallery and this was accompanied by the publication of *Unit One: The Modern Movement in English Architecture, Painting and Sculpture* with an introduction by Herbert Read.

But more important for the development of the New Architecture was the foundation in 1933 of MARS with Wells Coates as chairman and Maxwell Fry as vice-chairman. Adopting the CIAM programme, the group set out its aims with continental vigour:

'To formulate contemporary architectural problems,
To represent the modern architectural idea,
To cause this idea to penetrate technical, economic and social circles,
To work towards the solution of the contemporary problems of architecture'.[7]

With the backing of the *Review* (Hastings was the Press Officer for MARS, Shand its Liaison Officer and John Betjeman, the assistant editor of the *Review*, one of the founder members) MARS set out to purify modern architecture in England and to ensure active English participation in CIAM. The distinction between the *modernistic* and the modern was to be ruthlessly enforced; Wells Coates refused membership of MARS to those, like Emberton and Wornum, who sat on the stylistic fence, and even to Howard Robertson, as being 'people who are popularly and notoriously known as "modern" architects and obviously do not qualify in our sense'.[8]

The arrival of the continental emigrés and the formation of English groups such as MARS, 'Unit One' and Tecton, invigorated the architectural debate. But quite as important in establishing an image of modern architecture for public consumption were the first successes in actually building buildings which conformed to the new canon. Despite the vigour with which the *Review* and a number of other journals had presented the case of the New Architecture, the few English buildings that were acknowledged to be modern received minimal attention from the architectural press before 1933. It was *Country Life* that first published 'High and Over', the *Review* and the *Architecture and Building News* only started to give systematic coverage of modern architecture in England after 1933. As many were in addition remote and difficult to find, this absence of publicity meant that the achievement in England was still played down.

From 1934, this changed. In rapid succession the accredited modernists produced a series of highly successful buildings, a series of demonstrations of the New Architecture on English soil. At Highgate, Tecton completed the construction of 'Highpoint 1' (page 40), which demonstrated, for the upper-middle classes, that modern architecture could be programatic without abandoning the obvious attractions of comfort and luxury. At Bexhill, Chermayeff and Mendelsohn's 'De La Warr Pavilion' (page 41), showed how the New Architecture could brighten up an English seaside resort creating on land the delights normally offered only to those wealthy enough to embark on a cruise liner. At Lawn Road the 'Isokon Flats' (page 41), designed by Wells Coates for Jack and Molly Pritchard, showed that even those talents formed in England could develop and extend the idea of the Minimum Dwelling, a theme closely associated with the continental avant-garde. At London Zoo, Tecton built the Gorilla House and the Penguin Pool (page 42). The latter, with its resemblance to the constructions of Gabo, was not only a technical tour-de-force with its elegant concrete structure, but a witty solution to the problem of displaying an otherwise rather uninteresting bird, and one which was highly popular with the general public.

By 1938 when the MARS group exhibition 'New Architecture' opened at the New Burlington Galleries Modern Architecture was firmly established on English soil. Certainly the achievements were still limited; even in the *Review* the greater part of the buildings illustrated lay outside the canon of acceptability of the hard-line modernists represented by Tecton or the MARS group. Few of the buildings hailed as modern could match the best quality of work in Germany and France; caught in the role of

supporting the New Architecture, those like the editors of the *Review* were often not sufficiently critical of the buildings they championed.

But much had been achieved. The ideas defended by CIAM and the avant-garde on the Continent were now current in England. The radical work of the architects in England could no longer be dismissed as a mere 'footnote to Le Corbusier', but had acquired its own vitality and sense of direction. With the modern architecture in Germany proscribed, it was not totally unreasonable, even then, to see England, as Richards was to write in 1940, 'as the headquarters of modern architecture'.[9] In 1936/37 the dissensions and divisions within the modern movement in England could still be overlooked; the growing suspicion that 'functionalism' and the 'machine' alone were not enough to generate a New Architecture was still no more than a rumbling of discontent. The larger threat of war still lay well over the horizon.

To return to our initial question: the optimistic view of the development of the New Architecture set out in *Circle* was wholly plausible. Writing in 1937 it was entirely reasonable to assert that architecture, like the other arts, was passing through a transitional phase on the way to cultural unity. The New Architecture had already crossed political frontiers to flourish across Europe. Looking forward it was possible to see, beyond this immediate phase, a benign future stretching ahead in which a new vernacular produced by the simple and economical use of the new technology would bring as Le Corbusier predicted, 'happiness and a greater individual liberty, combined with the most complete greatness and collective vitality'.[10] Nor was this mood of optimism particular to *Circle*; only a few years before in *Technics and Civilisation*, Mumford had written:

'Here is a new environment — man's extension of nature in terms discovered by the close observation and analysis and abstraction of nature. The elements of this environment are hard and crisp and clear: the steel bridge, the concrete road, the turbine and the alternator, the glass wall . . . Every effective part in this whole environment represents an effort of the collective mind to widen the province of order and control and provision. And here, finally, the perfected forms begin to hold human interest even apart from their practical performances: they tend to produce that inner composure and equilibrium, that sense of balance between the inner impulse and the outer environment, which is one of the marks of a work of art. The machines, even when they are not works of art, underlie our art — that is, our organised perceptions and feelings — in the way that Nature underlies them, extending the basis upon which we operate and confirming our own impulse to order. The economic: the objective: the collective: and finally the integration of these principles in a new conception of the organic — these are the marks, already discernible, of our assimilation of the machine not merely as an instrument of practical action but as a valuable mode of life.'[11]

Sources

1 Blomfield, R: 'Is Architecture on the Right Track', *The Listener*, 1933, X, p 124
2 Martin, J L: 'The State of Transition', *Circle*, 1937, pp 216–7
3 ibid p 215
4 Pevsner, N: *Industrial Art in England*, Cambridge, 1937, p 160
5 ibid p 160
6 'Europe Discusses the House' editorial, *Architectural Review*, December 1928, p 222
7 'The MARS Group Manifesto' quoted in Gould, J *Modern Houses in Britain, 1919–1939*, London, 1977, p 14
8 Canacuzino, S: *Wells Coates, A Monograph*, London, 1978, p 47
9 Richards, J M: *Introduction to Modern Architecture*, London, 1940
10 Le Corbusier: 'The Quarrel with Realism', *Circle*, 1937, p 68
11 Mumford, L: *Technics and Civilisation*, New York, 1934, p 356

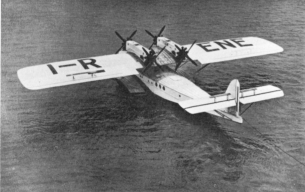

The New Design: Vernier Depth Gauge and Dornier
'Superwal' Seaplane

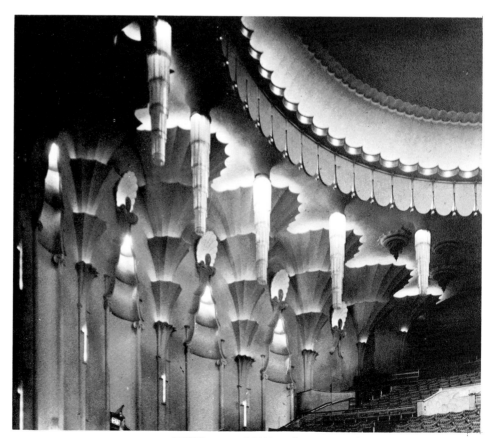

W E Trent and E Wamsley Lewis: 'The Victoria Cinema',
London, 1930

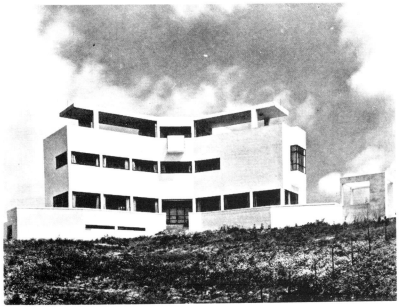

Amyas Connell: 'High and Over', Amersham, 1929

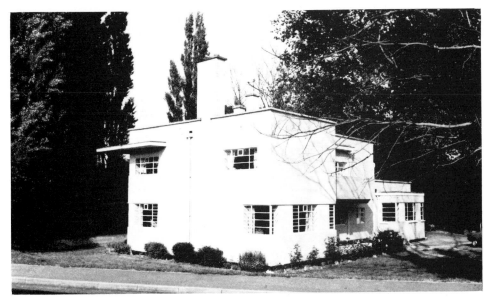

T S Tait: 'Le Chateau', Silver End, 1927 – 28

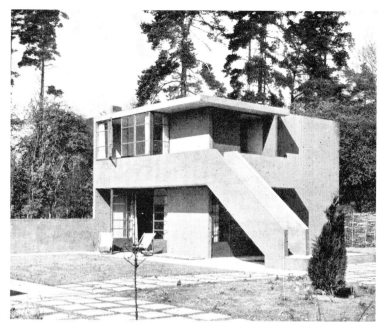

Colin Lucas: 'The Hopfield', St Mary's Platt, Kent, 1933

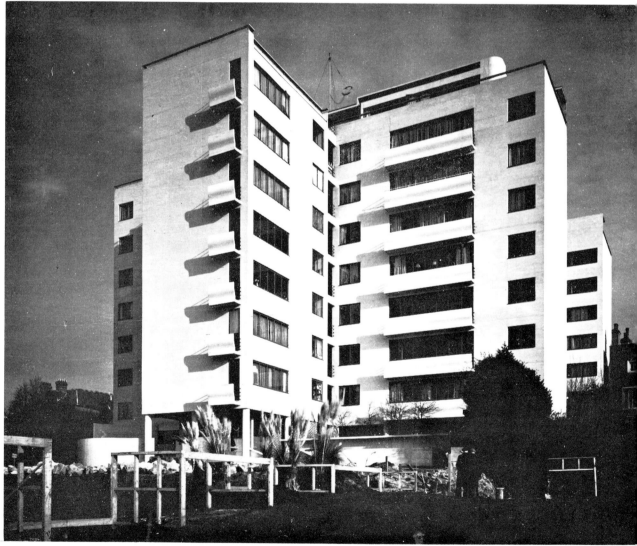

Tecton: 'Highpoint 1', Highgate, 1935

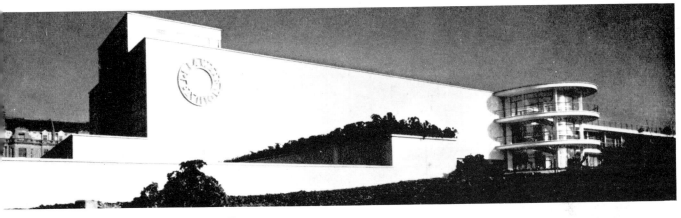

Erich Mendelsohn and Serge Chermayeff: 'De La Warr
Pavilion', Bexhill, 1935

Wells Coates: 'Lawn Road Flats', Hampstead, 1933

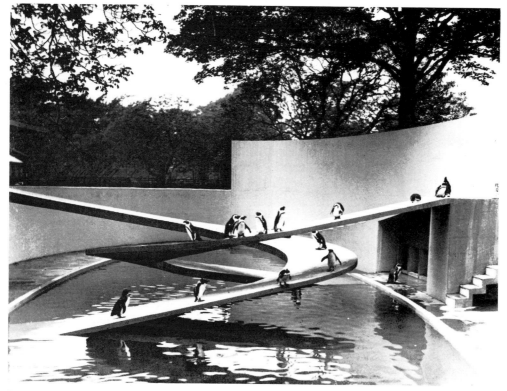

Tecton: 'Penguin Pool', London Zoo, Regent's Park, 1934

art and life John Gage

'This new awakening of the arts is not merely a fashion, but has its basis in the psychological, economic and social needs of the present moment.' (J L Martin, 'The State of Transition', in Circle)

Unlike some of the more hermetic art-groupings of the early 1930s, Circle from the first sought to present its ideas and aims in the widest cultural context. The editorial foreword proposed that Constructive art should be related 'to the whole social order':

'The fact that [the ideas represented by the work in this book] have, in the course of the last twenty years, become more crystallized, precise, and more and more allied to the various domains of social life, indicates their organic growth in the mind of society and must prove that these creative activities cannot be considered as the temporary mood of an artistic sect, but are, on the contrary, an essential part of the cultural development of our time.'

This was a view which had animated a number of modern movements on the Continent in the 1920s, notably Le Corbusier's and Ozenfant's L'Esprit Nouveau, but, with the very recent exception of the English Surrealist movement, it had hardly emerged within British art since Ruskin and Morris in the nineteenth century. The section devoted to 'Art and Life' in Circle thus offers a special promise of adventure, and we must look at the terms in which 'life' was to be understood. The section was, in fact, a somewhat miscellaneous collection of material, dependent, no less than other parts of the publication, rather on chance contacts and enthusiasms than on a rigorous editorial policy; and, as might have been expected from the nature of the case, the contributions could hardly be classified in any very clear-cut way.

Moholy-Nagy's note on 'Light Painting', for example, which deals essentially with colour in the environment, might equally have found a place in the sections on painting or architecture beside the contributions of Winifred Dacre (Nicholson) or Alberto Sartoris on the same subject. Lewis Mumford's vigorous attack on the traditional cult of permanence in architecture, 'The Death of the Monument', could also belong with the notes on town-planning by Maxwell Fry and Yorke and Breuer. And yet it is of the essence of Circle that these sectional demarcations should be blurred, just as Constructive art destroyed the traditional boundaries between painting and sculpture. The treatment of all the forms of expression and use was informed by an awareness of the ramifications of art and architecture in psychology and technology, in music and the natural sciences, and even — although this was hardly more than

implicit in the occasional references to the obstructive dependence on private enterprise — in politics. We shall thus find many non-aesthetic questions aired in all parts of the publication.

Perhaps the most surprising absentee among the topics of general concern presented by Circle is psychology, of which the only sustained discussion is in Herbert Read's 'The Faculty of Abstraction' in the section on painting. But Read's current interests were very much with Surrealism, a movement with which Circle had very little sympathy (as usual in the English context, these affiliations should not be taken as being exclusive: although Mondrian singled out Surrealism for especial attack in his Circle article, the headquarters of English Surrealism, E L T Mesens's London Gallery, also mounted the Constructive Art exhibition in 1937, and its chief organ, The London Bulletin, published work by artists from either camp, as well as by those, like Moore, who had their minds, as well as their feet, firmly in both). He looked to anthropology and psycho-analysis, rather than to experimental psychology for what might prove fruitful in the study of the arts; and he was concerned chiefly with subject-matter:

'Just as Surrealism makes use of, or rather proceeds on the assumption of, knowledge embodied in psycho-analysis, so abstract art makes use of, or proceeds on the basis of abstract concepts of physics, geometry and mathematics.'

The only contributor who seems to have been concerned to explore the relationship between psychology and creativity itself, on the basis of recent research, was Walter Gropius, whose essay, 'Art Education and State', opened the 'Art and Life' section. It was a brief extract from a much longer article in The Year Book of Education for 1936: 'Unity between art and technique as the aim of public education in art', which seems to be the first detailed account published in any country of the curriculum of the German Bauhaus, directed by Gropius between 1919 and 1927, and which he had already introduced to English readers in a summary form in his book, The New Architecture and the Bauhaus, published by Faber in 1935. This had been introduced by Frank Pick, who, as Chief Executive of London Transport, had been one of the first public patrons of avant-garde commercial and architectural design in this country. Gropius's contribution to Circle does not mention the Bauhaus (which his other English publications implied was still in being, although it had in fact been closed by the Nazis in 1933); he was simply concerned to outline the general principles of art-education on Bauhaus lines, advocating an experimental approach to manual training, and to designing. His plea for an integrated art-training from the

kindergarten to the advanced schools was related to the integrative doctrines of gestalt-psychology, which had been studied at the Bauhaus in the mid-1920s:

'It is the sense of coherence in what he learns, and not the accumulation of organically unconnected scraps of knowledge, which makes the adolescent harmonious, far sighted and productive'.

In marked contrast to this tightly-structured didacticism of Gropius was the next contribution, a short and unillustrated note on choreography by Léonide Massine, the veteran character-dancer of the Russian Ballet, who, as the Chinese Conjuror in *Parade* (designed by Picasso) and as the shop-assistant in that most popular of the Diaghilev ballets in England, *La Boutique Fantasque* (designed by Derain), had brought humour and novelty to the dance in the immediately post-war years. Massine was now responding to some very specific questions on the role of abstraction, of drama and of politics in the ballet, and his brief discussion reflects his pre-occupation with the rather more serious and grandiose work he was undertaking in the 1930s. He felt that he was able to produce drama in the dance 'without destroying the classical and purely abstract elements of the ballet', and he sought to transcend the limitations of the human body 'by projecting [it] further in space than human muscles allow through the multiplication of the number of dancers and the creation of compositions with the chorus'. It was this emphasis on large-scale *ensembles* which perhaps explains how Massine attracted the interest of *Circle*, for one of these new symphonic ballets, to Beethoven's Seventh, had originally been designed by Ben Nicholson. Massine conceived of this ballet very much in terms of the cycle of the creation and destruction of the world:

'I saw in the first scene the basic forces of nature', he wrote in his memoirs, 'Earth, Air and Water, assembled by the spirit of Creation. Plants, birds and animals appear. Finally Man, Woman, and the Serpent emerge from the living rock. The second scene I conceived as the story of man's guilt and despair, symbolised by Cain and Abel and the introduction of death with man's first murder. The third scene introduced the gods of Olympus. Beginning in a mood of gaiety, I created a choreographic movement which led on to the debauched bacchanal of the Fourth Movement, concluding with the destruction of the world by Fire'.

Nicholson's designs of 1934 included dynamic, Miró-like biomorphic compositions (no 69) and austere geometrical abstractions (no 70), but they were not used. When *Seventh Symphony* was finally staged at Monte Carlo in May 1938, the severely classicising sets were by Christian Bérard (no

55), who had, as Sacheverell Sitwell was to write, 'managed in a masterly way to produce effects of classical calm out o the simplest of means'. *Seventh Symphony* was, he said, 'the most solemn, the most classical of all Massine's works . . . Perhaps, all told, . . . the summit of Massine's achievement where serious ballet is concerned'. It was essentially as a modern classical master that Massine found his place in *Circle*.

Although Massine had choreographed the remarkable Russian Revolutionary ballet, *Le Pas d'Acier* (The Steel Way) for Diaghilev in 1927, his response in *Circle* to a question about the political potential of ballet was entirely negative: 'I think that political tendencies do as much harm to politics as to the dance'. It might, however, have been expected that the next contributor to the 'Art and Life' section of the publication would have taken a more positively political stance. László Moholy-Nagy, who had been called to the Bauhaus by Gropius in 1923, settled briefly in England from 1935 to 1937, and his English reputation and activity was based almost entirely on his work as a photographer and film-maker in a social-realist vein. Although he contributed a short abstract sequence to Korda's film of H G Wells's *Things to Come* (1936), his chief English work, apart from commercial design, was the documentary film about fishermen, *Lobsters* (1935/6), made very much under the influence of John Grierson, and the photographic illustrations to Mary Benedetta's *The Streetmarkets of London* (1936). A series of photographs of the docklands of Hull, made while Moholy was staying with Leslie Martin early in 1937 (no 64), remained unpublished until very recently.

In an article, 'Subject without Art', published in *The Studio* in 1936, Moholy had written:

'I am convinced that the subconscious can . . . absorb the revolutionary social ideas by means of congenial conceptions expressed in a specific medium. The non-political approach to art is thus transformed, by means of the subconscious, into a weapon of an active attitude to reality, pressing for the solution of the urgent social and economic problems of today . . . Painting, photography, film and light display no longer have any exclusive sphere of activity, jealously isolated from one another. They are all weapons in the struggle for a new and more purposive humanity'.

His concern to exploit technological developments in art was itself obstructed, he felt, by an economic system inadequate to handle the results of technological advance. The chief obstacle to his new 'Light-Architecture', which

would animate the interior and the environment by means of moving projections of light and colour, was, as he wrote in *Industrial Arts* the same year,

'the great gulf which lies between man and his own technical creations, the deeply conservative persistence of outworn forms of economic structure in spite of the fact that production has been revolutionised, and the spreading of an anti-biological mentality which turns the life of everybody, workers and employers alike, into a mad speed-race, without a moment for rest.'

Of the coming social and political struggle there was only a hint in Moholy's article on 'Light Painting' for *Circle*, which took the form of a plea for an Academy of Light, and was illustrated by a single photogram from a rather earlier phase in his activity. The most recent of a number of Moholy's works illustrated in the publication dated from 1931.

Clearly for *Circle* constructive art did not include those aspects, 'the press photos, book illustrations, theatrical lighting, advertising of films, and illuminated advertising' which were now central to Moholy-Nagy's preoccupations. Breuer's Kharkov theatre, exhibitions designed by Gropius and Breuer, Fischer and Molnar, Tecton's zoo buildings, Van Loghem's public swimming-bath and Leslie Martin's pre-fabricated seaside chalets were among the few indications in *Circle* of an ebullient and populist attitude to art. Among the contributors to 'Art and Life', the only commercial designer, apart from Moholy himself, was the German typographer Jan Tschichold, whose short and well-illustrated statement on the new typography emphasised the need for clarity, to be achieved above all through contrast. For Tschichold at this time this meant contrasting typefaces and an asymetrical layout like that of *Circle* itself. Tschichold also sought to relate the principles of typography to wider developments in art: in an article in *Industrial Arts* in 1936, 'Abstract Painting and the New Typography', he had suggested that typography, like architecture, was 'dependent upon the new painting which has provided the model on which both are working'. Possibly through Peter Gregory, a director of the publishers Lund Humphries, and a patron of contemporary artists, who had invited him to England in 1935 and arranged a small exhibition (no 74), Tschichold had come to know Ben Nicholson, whose reliefs he discussed in an article in *Axis* that same year. *Axis* in its turn had proposed that 'the sooner Tschichold's theory and practice penetrate to England the better', and certainly his presence came to be strongly felt even before he came to design for Penguin Books after the

Second World War. His book of 1935, *Typographische Gestaltung*, reviewed in *Axis* (see document p 70) and cited in the bibliography of *Circle*, seems to have been prepared for an English translation as early as this period (no 72; it was not finally published here until Ruari McLean's version, *Asymmetric Typography* appeared in 1967). For Lund Humphries he designed letter-headings, and *The Penrose Annual* for 1938 (no 75) according to his new principles. It was perhaps he who introduced the single El Lissitzky reproduced in *Circle*, a *Proun* of c.1923, which he had also used for the chapter on typography and painting in *Typographische Gestaltung*.

Perhaps the most pervasive non-aesthetic concern of *Circle* was the belief in the inter-relationship of the arts and the natural sciences.

'However dangerous it may be to make far-reaching analogies between Art and Science', wrote Gabo in his introduction, 'The Constructive Idea in Art', ''we nevertheless cannot close our eyes to the fact that at those moments in the history of culture when the creative human genius had to make a decision, the forms in which this genius manifested itself in Art and Science were analagous'.

In the 'Art and Life' section of the publication, the 'Note on Biotechnics' by the Czech architect Karel Honzig took into the realm of an evolutionary structural analysis those analogies between plant forms and the forms of artefacts which had recently been the subject of a popular photographic study, Karl Blossfeldt's *Art Forms in Nature* (1928), re-issued in a second English edition in 1935. Honzig was aware that nature presented many obstacles to the belief that form follows function, but he felt nonetheless that natural forms were expressive of the forces that had shaped them, and that they might thus be compared usefully with functional expression in architecture. The example he took was the ribbed leaf-structure of the Victoria Regia lily (no 63), which had proved such an inspiration to Paxton in the design of greenhouses and the Crystal Palace, and which Honzig related to the concrete skeleton of the Fiat factory in Turin.

But by far the most distinguished contributor to this theme in *Circle* was the Cambridge crystallographer J D Bernal, whose essay, 'Art and the Scientist' was included in the section on sculpture. Bernal was very interested in the work of Gabo, with whom he was in touch late in 1936, but his *entrée* to *Circle* had probably already been effected by his friend Margaret Gardiner. Later in 1937 Bernal was approached by Barbara Hepworth to write the foreword to the catalogue of her exhibition at Alex. Reid and Lefevre

(no 61). This he did, disclaiming any aesthetic competence, and stating that his note 'Simply expresses the relation of an extremely refined and pure art form to the sciences with which it has special affinities'. In the event these affinities were seen to be rather with Neolithic art than with a specifically scientific vocabulary; but in *Circle*, and in discussions with Hepworth before the exhibition, he had touched on some far more directly fruitful connections.

But by far the most distinguished contributor to this theme in *Circle* was the Cambridge crystallographer J D Bernal, whose essay, 'Art and Scientist' was included in the section on sculpture. Bernal was very interested in Gabo's work, with whom he was in touch late in 1936, but his *entrée* to *Circle* had probably already been effected by his friend Margaret Gardiner. Later in 1937 Bernal was approached by Barbara Hepworth to write the foreword to the catalogue of her exhibition at Reid and Lefevre (no 61). This he did, disclaiming any aesthetic competence, and stating that his note 'Simply expresses the relation of an extremely refined and pure art form to the sciences with which it has special affinities'. In the event these affinities were seen to be rather with Neolithic art than with a specifically scientific vocabulary; but in *Circle*, and in his discussions with Hepworth before the exhibition, he had touched on some far more directly fruitful connections.

'The biggest criticism that is levelled against constructive art', she wrote to him (no 62) 'is that it is limiting − but it seems to me the freest possible thing − unlimited in its scope & your idea of regular irregularities seems a proof of this. When I spoke of the application of these laws to each material each size each idea I really do believe it to be a basis of constructive art because this seems to me to be one way of freeing every conceivable idea to its fullest intensity . . . what I am really interested in is your idea − your constructive idea in relation to sculpture (in particular!)'.

Bernal had in his *Circle* essay stressed the usefulness of a study of the large number of possible symmetries for the creation of harmony, particularly in architectural composition; and he also suggested how the use of free surfaces in modern sculpture, particularly that of Moore and Hepworth, might be seen as a recapitulation of mathematical forms. But his concern with art was far from being purely formalistic, or exclusively based on notions of the analogies between artistic structure and content. He welcomed the reaction against abstraction implicit in Surrealism, with its potential for the introduction of psychological procedures and biological forms, and more importantly, he was led by his Marxism to appeal for the closer identification of art with the needs of society as a whole, as he was to do for the sciences in his book, *The*

Social Function of Science (1939). The forms of Hepworth's sculpture, he wrote in her catalogue, 'require to be combined integrally with those of buildings to which they would give a completeness that is at present lacking'. And in *Circle* he wrote,

'The artist no more than the Scientist can occupy himself in permanent satisfaction with the contemplative and analytic sides of his work. Socially art is not complete unless it passes from the solution of problems to something of more immediate social utility.'

Such a development might involve a return to representation, 'but it should be a return on a different level of experience'. Traditional revolutionary art was not the answer, but neither could artists themselves be left to determine what the answer should be.

'Scientists and artists suffer not only from being cut off from one another but being cut off from the most vital part of the life of their times. How to end this isolation and at the same time preserve the integrity of their own work is the main problem of the artist today.'

The relationship of constructive art to science was still problematic because the relationship of both to society had not yet been clearly understood. *Circle* was hardly concerned to resolve the dilemma in theory, but in many of its examples of architectural practice − the hospitals, the schools, the low-cost workers' housing, the football stadium, the swimming baths, the farm − and generally in the belief in a planned environment, we do have a sense of a high degree of social commitment, of a vision of social organisation. It has remained a utopian vision.

important events and exhibitions in London 1933–39

events

1933 Foundation of *Unit One*.
Summer, Ben Nicholson meets Piet Mondrian.

1934 Walter Gropius arrives in London (stayed till 1937).
Fernand Léger and László Moholy-Nagy work
for A Korda on *The shape of things to come*.

1935 January, *Axis* founded.
László Moholy-Nagy and Marcel Breuer settle
in London.
László Moholy-Nagy makes *Life of the Lobster*.
New architecture at the London Zoo, 1935–36.
National government elected under Stanley Baldwin.

1936 Opening of Amedée Ozenfant's academy in London.

1937 Spring, Stanley Baldwin resigns, Neville Chamberlain
becomes Prime Minister.

July, Publication of *Circle*

1938 Publication of the *London Bulletin*.

September, Mondrian arrives in London.

1939

September 3rd war declared with Germany.

exhibitions

Mayor Gallery, Auguste Herbin.

'Experimental Theatre' Arthur Jackson, Paul Klee,
Joan Miró, Paul Nash, Ben Nicholson, John Piper and
Edward Wadsworth.
Zwemmer Gallery last '7 & 5' exhibition.

Lefevre Gallery 'Abstract & Concrete' painting and
sculpture exhibition, previously shown in Oxford, Cambridge,
Liverpool.
London Gallery October, Edvard Munch, catalogue by
Herbert Read.
December – January, László Moholy-Nagy (first London
exhibition of his work).
Mayor Gallery 5 American artists: Biederman, Calder,
Ferren, Morris, Shaw.
New Burlington Galleries June, First International
Surrealist Exhibition.
Duncan Miller 'Modern Paintings in Modern Rooms'
Leicester Galleries November, Sculpture and drawings
by Henry Moore

London Gallery January – February, 'Young Belgian artists,'
catalogue by E L T Mesens.
Exhibition on theme of musical instruments included work by
Georges Braque, Ben Nicholson and John Piper.
April – May Herbert Bayer.
May – June cartoons by Low.
June – July Oscar Schlemmer.
July, 'Constructive Art': Alexander Calder, Winifred Dacre,
Naum Gabo, Alberto Giacometti, Jean Hélion, Barbara
Hepworth, Eileen Holding, Arthur Jackson, László
Moholy-Nagy, Henry Moore, Ben Nicholson and
J C Stephenson.
Lefevre Gallery still-life paintings by Ben Nicholson.
October, 13 works by Barbara Hepworth.
London Gallery 'Constructions', Naum Gabo.
Mayor Gallery, Fernand Léger.

London Gallery 'Living art in England'.
Lefevre Gallery March, Ben Nicholson.
Whitechapel Art Gallery Artists International Association,
abstract work.
Guggenheim Jeune, London, 'Abstract and Concrete Art'

47

reviews of Circle

New Statesman

Anti-humanism

This book, which contains some 120 photographs of painting, sculpture and architecture, and a couple of dozen articles, is a manifesto, representative of one current tendency in visual art. Its immediate source is the 'functional' architecture of Corbusier, Gropius and their rivals, which has apparently influenced painters like Mondrian and sculptors like Gabo. More profoundly, this art may be considered the natural outcome of the machine-age. Men invented engines to save their labour and increase their wealth. But the means have now become an end. And not only are machines now worshipped as beautiful, but men seek themselves to resemble their idols. The Totalitarian State is ideally a society of which every member acts as mechanically as a valve or a piston, discarding all individuality. The modern boy's passionate enthusiasm for wireless and motor bicycles which he treats as ends, makes him accept a conception of society which treats him merely as means. Man, it seems, has evolved from the unreasoning beast only to become the unreasoning machine. I know of no spectacle more inhuman and more disgusting than the demonstrations of drill organised in Nuremberg and Moscow, of which this book shows the aesthetic equivalents. In Germany, it is true, 'modernistic' art of all sorts is indiscriminately condemned as Bolshevistic; and in Russia it is similarly condemned as *bourgeois*. (Probably the personal taste of the two dictators, who in this respect are remarkably similar, is responsible for this.) But the rigidity and conformism cherished by the Totalitarian States would find a perfect expression in the geometrical inventions illustrated in this book. These artists pursue and achieve impersonality, and their work is as arid as a parade-ground. Ruskin said 'The circle is the ugliest of all curves.' One might add that the art of which *Circle* is the manifesto is the dullest of all arts.

In fact rigid geometrical forms can be used to make beauty. A Doric temple is constructed with curves of extreme subtlety, but could be exactly described in mathematical terms. But there was within it the statue of god, and there were figures on its frieze and in its Gothic architecture (which was much more 'functional') evolved largely as a scaffolding to support anthropomorphic sculpture and stained glass. Geometrical beauty in fact is inferior, or rather subservient, to the beauty which is specifically human. An aeroplane or a bridge lacks all the vices of bad art, but also lacks the highest virtues of good art: its aesthetic excellences are mainly negative.

In architecture a reformation has been necessary. In the nineteenth century architecture disappeared from Europe, and we have had to begin again. Corbusier, whom I take to be the greatest living architect, has a Calvinistic turn of mind, but has, in fact, never been a true functionalist. He insists that beauty is something beyond practical fitness, and has written of Greek, Byzantine and Renaissance buildings with the admiration they deserve. (His farm, undoubtedly, is aesthetically the best object illustrated in this book.) His less intelligent disciples have imitated his puritanism without sharing his sensibility. And even when they talk of functionalism, they design buildings which in fact are unfunctional, because ill-adapted to the climate. (Immensely large windows and flat roofs have become a cliché and an imposition.) The vulgarity of Oxford Street and the squalor of Peacehaven are symptoms of capitalist chaos and incompetence, but the termitaries designed by functionalist architects are equally unworthy of the species which has produced Shakespeare and Beethoven and Michelangelo.

When painters and sculptors are so muddle-headed as to use the geometrical forms which are proper to architecture, the results are merely boring and silly. Picasso, Braque and the other Cubist painters (who are represented in this book) have never sunk into geometry. Messrs. Mondrian, Ben Nicholson and Moholy Nagy making their objects, more or less tastefully, with ruler and compass are like children playing trains. Machines exist to transmit emotion. But what can be the point of something that looks like a machine, and that transmits neither power nor emotion?

If the illustrations in this book are insignificant, the text is, for the most part, nonsensical. Mr Herbert Read, whose intellect is, if I may venture to say so, conspicuously superior to his aesthetic sensibility, writes interestingly about conceptual art, but it is too evident that words are not the natural medium of most of these writers. Let me quote from Mr Ben Nicholson:

'It must be understood that a good idea is exactly as good as it can be universally applied, that no idea can have a universal application which is not solved in its own terms, and if any extraneous elements are introduced the application ceases to be universal.

"Painting" and "religious experience" are the same thing. It is a question of the perpetual motion of a right idea.'

If I were given a box of paints, or a chisel and a block of marble, I could not produce anything more meaningless than those sentences. And as writers Miss Barbara Hepworth and Mr Gabo and many of the others are no more competent than Mr Nicholson. These "Constructive Artists," as they call themselves, are goose-stepping up one blind alley, while the Surrealists lurch up another in the opposite

direction. Meanwhile the real artists, like Picasso, Matisse, Braque, Bonnard, Rouault, go on magnificently painting. In the younger generation, it is true, we cannot find their equivalent, and the next great painter who does appear will, no doubt, be very different from any of these. But he will be neither a geometrician, like Mondrian, nor a mere illustrator, like Dali. For the qualities we admire in Picasso and Matisse are fundamentally the qualities we admire at Athens and Ravenna, in Giotto, in Rubens, in Chardin and Cézanne — the plastic expression of personal and human emotion. R M

[*New Statesman* Vol XIX no, 336, 31 July 1937, p 190]

Times Literary Supplement

Art in the air: problems of the machine age
Though, according to Coleridge's definition — 'a principle or opinion taken up by the will for the will's sake, as a proof or pledge to itself of its own power of self-determination' — constructive art must be pronounced to be a heresy, it would be idle to deny its importance and significance in relation to the time of day. Given the world as it is, and the persistence of the artistic impulse, something like it was bound to happen. It is, or appears to be, a third and exciting stage in the effort of the artist to adjust himself to the machine age. The first stage, identified with William Morris and his associates, was one of rejection: the second, well illustrated by the earlier paintings of Mr Frank Brangwyn, the lithographs of Joseph Pennell, the 'industrial landscapes' of Sir Charles Holmes and, it might be added, a temporary phase in the work of Mr Paul Nash, was one of acceptance to the extent of representing the characteristic forms and effects of the machine age pictorially: and the present stage is one of identification with its activities for their redemption. Just as the older work of art was described as 'parallel' to the work of nature, so the work of constructive art might be described as 'parallel' to the machine product. In architecture the adjustment to the machine age has to a great extent been made; in painting and sculpture it is still compromised by clinging to the forms and methods of the age of handicraft; and it is not without irony that this book should include painting, sculpture and architecture as if they were the same in principle according to the canons of constructive art. How far the hesitation of painting and sculpture to take the plunge into the machine age is due to economic reasons and how far to reason of prestige, the desire of the artist to remain an 'artist' in the older meanings of the word, it would be difficult to say; but Mr J D Bernal seems to put his finger on the situation when

he says 'paintings and sculptures are purchasable objects, not parts of well-conceived social construction'; and, in the light of the illustrations to this book, we are inclined to agree with M le Corbusier that, 'the word is with the architects, if I may be pardoned for saying so.' It might be objected that buildings are also purchasable objects; but the point is that they are, as paintings and sculptures used to be, purchasable for utilitarian reasons, the constructive art in them being thrown in.

So far as painting and sculpture are concerned, constructive art is still 'in the air.' It has emancipated itself from the responsibilities of painting and sculpture, implied in if not compelled by their materials, which made the picture and the statue 'purchasable objects,' but, by clinging to their forms, it has not yet, except in application to objects of utility, accepted its role in 'well-conceived social construction.' Its productions, in painting and sculpture, are 'schemes' of such participation, but still in the form of 'purchasable objects,' in which the materials play only the part of padding the formal effect. That, as in the paintings of Mr Ben Nicholson and the carvings of Miss Barbara Hepworth, the materials should be cherished for themselves only emphasises their relegation, and the aesthetic objection to constructive art in painting and sculpture is that it lacks unity. You respond to the formal effect, and then you admire the treatment of the materials, as you do not when the materials are allowed their full responsibilities, of representation in painting and sculpture and of shelter in architecture. In the fulfilment of these responsibilities they disappear; denied them they are at a loose end. More than one writer in this book insists that, for the first time, constructive art has made form and content one and the same thing. That may be true; but it is only at the cost of extruding substance, which is a factor that must be reckoned with in the unification of any work of visual art.

All the essays in this book are interesting and stimulating, those by Mr Herbert Read and Mr N Gabo particularly so; and the response to them of most readers who have thought about the subject will be one of cordial agreement sprinkled with 'buts' — the 'buts,' on analysis, being chiefly due to an initial difference of opinion not so much about this particular phase of art as about art in its essence. Representation never was the 'aim of painting and of sculpture: it was and is merely a condition of the unified expression of the constructive impulse in concrete materials. Terms like 'pure' and 'absolute' art ought to be avoided in talking about constructive art. Pure art can only mean completely unified art, single in its effect, and is more truly applied to a painting by Titian than to a 'constructive' painting or sculpture. Such are best looked upon as 'rehearsals' of the part the artist will

49

presently play in the organization by feeling of the structure of society. If, in looking at the illustrations to this book, the works in architecture are more satisfying than those in painting and sculpture the reason is precisely that they are, or appear to be, more completely unified; and if, as M le Corbusier claims, 'the word is with the architects,' there is a simple explanation in the easier transition from handicraft to machine conditions in architecture than in the other arts. The constant, in any case, is formal sensibility. Therefore its 'rehearsals' in painting and sculpture are to be encouraged rather than derided.
[*Times Literary Supplement*, 24 July 1937, p 539]

The Listener

It is forced upon us, depressingly and persistently, that the whole pattern of our life is shaped by our inability to cope with the machine and the new forces it has released upon the world. *Circle*, with 21 writers, 29 architects, 22 painters, 10 sculptors and some 260 plates, sets out to reveal how contemporary artists — architects, painters, sculptors — are welding the new material into some semblance of a culture, to align their achievements with contemporary life and 'to gather here those forces which seem to us to be working in the same direction and for the same ideas'. This direction, these ideas, this art are termed 'constructive' — a more definite word than abstract or non-figurative.

Constructive art is essentially a machine art; it stands for order, precision, science, regimentation; continually in the pages of *Circle* we find comparisons between constructive art and science (there is an article on Art and the Scientist, and another on Biotechnics), it is an art of laws and inflexibility, its aim is 'perfection'. 'Since the beginning of Time man has been occupied with nothing else but the perfecting of his world. To find the means for the accomplishment of this task the artist need not search in the external world of Nature; he is able to express his impulses in the language of those absolute forms which are in the substantial possession of his art. This is the task which we constructive artists have set ourselves, which we are doing and which we hope will be continued by the future generation' (Gabo).

The idea of a perfect world is unthinkable; but perfection, of a limited kind, is an attribute of the machine. It is not an attribute of man. And in accepting the limited kind of perfection attainable by machines, constructive art has, it seems, tended to ignore the needs of man. It is significant that the most emotionally satisfying thing in the book is Stonehenge, beautifully photographed by Mrs Giedion-Welcker and Professor Gropius.

The book is divided into four sections: Painting, Sculpture, Architecture, Art and Life. The essays inevitably vary in quality, and there is not space for individual comment; of particular interest are those by Herbert Read, le Corbusier, J M Richards, Maxwell Fry, Marcel Breuer, R J Neutra, S Giedion, Walter Gropius, Karel Honzig and Lewis Mumford. The most satisfactory section is the architectural, whose illustrations cover a wide range of building purposes and whose writers seem more certain of themselves and their territory, both architectural and social. This is to be noticed, too, in the work reproduced. Architecture, since such men as Telford and Paxton, has been well ahead of painting and sculpture. It has lost its first self-consciousness in the face of the machine. So, if one remembers Marinetti and Wyndham Lewis, has painting; but less completely. It is all right for artists to stand in awe of scientists, but it is all wrong for art to stand in awe of science. Architecture has assimilated the machine, the 'function equals beauty' phase has passed, and a wider threshold is trodden. Le Corbusier, as ever, has excellent grasp of the situation. He says he can 'when a wall or partition presses down on me . . . if the place is suitable, call in a painter and ask him to register here his plastic thoughts, and at one blow open all the doors to the deep land of dreams — especially there, where there is no real depth'.

That seems an excellent statement of the place of painting in relation to architecture, but it shows the paintings reproduced here as lacking in lyricism, too bound to science. This is not meant to belittle the importance and achievements of constructive art which stands as one of the most vital cultural advances of this century. Constructive art is clearly, the only *sort* of art truly at one with contemporary architecture, but it has certain characteristics as yet unresolved in relation to the machine and to man, to living; it is rather inhuman, rather too perfect. Like the rest of us, it has not learnt to cope properly with the machine. But it will grow, for it is vital; and to all who are concerned with the growth of art into a factor of importance to more than the elite, into an integral part of life rather than an unnecessary adornment, to these *Circle* is of great importance.
[*The Listener* Vol XVIII no 447, 4 August 1937, pp 259–260]

London Mercury

Abstract art
This book is a survey of certain related tendencies and ideals in contemporary painting, sculpture, and architecture, presented in the form of essays by different writers and artists with a collection of reproductions of works in these three arts. It is impossible accurately to collect

the ideas put forward under the name of a single movement, but roughly one may say that the painting and sculpture dealt with is of the abstract type which evolved from cubism. In his essay, it is true, M Le Corbusier objects to this use of the term abstract on the ground that the so-called abstract painting is really fundamentally concrete. Whether this is in any sense true of much of the painting illustrated in the book or not, the term can be justified as applied to all of it and conveys best the sort of work with which the authors are concerned. The architecture is of the type associated above all with the name of M Le Corbusier himself, in which the fullest use is made of the possibilities of modern building materials.

At the present time the first novelty of abstract art is wearing off, and the opportunity is being seized by those who never really came to appreciate it to renew their attacks. There is also a tendency on the part of certain super-realists to return to a very unpleasant kind of realism, as Mr Dali in his coloured photograph technique. A book on abstract art by those who believe in it is therefore very welcome. The main position also seems to be quite admirable. I take it to be that put forward by one of the editors, Mr N Gabo, in his essay, *The Constructive Idea in Art*, which precedes the sections dealing separately with the arts. Mr Gabo defines the constructive idea as follows: 'It has revealed an universal law that the elements of a visual art such as lines, colours, shapes, possess their own forces of expression independent of any association with the external aspects of the world; that their life and action are self-conditioned psychological phenomena rooted in human nature; that these elements are not chosen by convention as words and figures are, they are not merely abstract signs, but they are immediately and organically bound up with human emotions.'

Unfortunately in detail the book is far less satisfactory. There is too much use of such phrases as *dizzying experiments* and such nonsensical phrases as *completely handicap*. Even where there is a genuine argument it is often obscured by a strange twist in the writer's mentality, such as that which leads Mr Gabo in discussing form and content exactly to reverse the meanings of the words. Both effusiveness and obscurity are particularly to be regretted, as the book certainly appears to be a serious attempt on the part of its authors to propound ideas in which they sincerely believe, and it has none of the bombastic romanticism of the Marinetti kind. It is impossible to criticize the essays in detail, but it may be noted that they share in common a very comforting optimism. One writer even goes so far as to see in the machine a cause of increased liberty. At the present moment it may be difficult to be convinced of this, but one must admit that any hopes one may have for it must rest in the existence of some who still refuse to believe it to be a lost cause.

Noticeable among the illustrations is a series of very beautiful bridges by Mr R Maillart, while the essay on his work by M Siegfried Giedion is perhaps the most interesting and instructive in the book. In view of their simple, unaffected beauty it is curious to read of the criticism of the chairman of a Swiss committee: 'I am sick of these pastry-work bridges.' *William Gibson*
[*London Mercury* Vol XXXVI no 215, 9 September 1937, p 486]

The Studio

Not intended to be an impartial and disinterested survey of every kind of modern art, this book endeavours to advance the 'constructive trend', being inspired by the idea that a new cultural unity is slowly emerging. According to the constructive idea, philosophical wondering about real and unreal is idle. So, perhaps, it may be, yet the kind of work represented here remains speculative. Indeed, the statement that a new cultural unity is emerging does not seem to hold water. It was supposed to be slowly emerging ten years ago when it was disrupting the traditions of architecture, painting and sculpture – and now there is a strong reaction against it. How little cultural unity there is in Europe can be seen at the Paris Exhibition, where something very like the 'constructivism' discussed and illustrated in this book makes such an odd contrast with completely opposed aims. Between the two the observer who has any old-fashioned notions about beauty may wonder whether any culture is left in Europe at all. The abstract painting and architectural projects with which *Circle* is concerned is already a lost cause in many ways. The editors may be credited with gallantry in supporting it. It may be that, being 'lost' in no way invalidates what essential truth it contains, but new it is not. Everyone interested in art must consider whether the process of dehumanising and materialising which it represents, has not gone far enough, whether a really new cultural unity, if the world continues sane, or if culture is to be gracious instead of fearsome, will not be found in humanism.
[*The Studio* Vol CXIV no, 536, November 1937, p 277]

Burlington Magazine

Not a manifesto, nor merely a statement of achievements, this book is a collection of essays by members of the contemporary movement from many nations. It has the kind of value of a successful conference, pointing to the future,

51

rather than the past. It is remarkable not only in its scope, including painting, sculpture, architecture, town planning, and many other aesthetic aspects of civic life, but also in its insistence on the relatedness of these activities, and in the community of understanding and intention among these writers which it evidences.

Problems are conceived and discussed on the social as well as the individual level, and the fundamental aim of the publication is to demonstrate the relationship of each discipline to the other, and of constructive art as such to the social order.

There could be no better refutation of the charge of escapism, so often levelled at the so-called 'abstract' artist (a term here rightly disclaimed), than the concreteness with which socio-technical problems are realized, in the best of these essays. Nor is there any better answer to the sillier charge of personal advertising than the emphasis laid by several contributors on the necessity of an anonymous tradition. It may fairly be claimed, with less risk of misunderstanding as a result of this book, that constructive art is that very social realism — though less informed on economic and political questions than one could wish — which an important section of its decriers are themselves in search of.

The production and illustration are excellent, and everything required in the way of indexes, bibliography, list of exhibitions, etc., is provided. A C S
Burlington Magazine, Vol LXXI 1937, p 246]

articles and extracts

This section contains reprints of articles and extracts relating to *Circle* and its contributors.

Herbert Read

In the criticism of modern art we have reached a stage at which the everyday vocabulary of criticism is proving inadequate and therefore confusing. Developments of the last twenty years have given rise to various new types of art which, although they may have their parallels in past epochs, have never existed as self-conscious entities. All this time art criticism has been busy inventing new terms — naturalism, impressionism, pointillism, post-impressionism, expressionism, fauvism, cubism, constructivism, super-realism — all of which have distinct meanings, and all of which are justified by new developments of technique or manner. The group of terms I wish to try and define more precisely in this note all arise out of the cubist movement.

Cubism, when it was first used, about 1908, denoted a certain distortion of natural appearances in the direction of plane surfaces and geometrical outlines. Cézanne, of course, had made simplifications in this direction, but the decisive moment for the application of the term 'cubism' comes when (as with Picasso) the simplifications pass beyond the degree of illuminating the nature or structure of the object represented, and take on aesthetic values of their own. The form of the composition, that is to say, is independent of the forms of nature. But 'cubism' has an historical significance, and should, I think, be confined to painting and sculpture which still retains a recognisable relation to natural objects — in which these objects remain as the theme of a geometrical distortion

Such is the usage of the term now predominating in serious discussions of modern art. The confusion begins with the further developments of the cubist movement. The distance between the painting and the natural object quickly increased between 1909 and 1914, until the natural object had no more than a perfunctory and scarcely distinguishable existence. Then artists began to call their work 'abstractions,' and the phrase *abstract art* gradually came into use.

We may note, in justification of the use of such a term, that:

(1) The notion of an art divorced from 'real' or natural objects was a possibility envisaged by Plato, and discussed by him in terms which signify 'absolute' or 'abstract' (*Philebus*, 51 B. See *Art Now*, pp 101-2).

(2) The notion has its parallel in modern poetry under the term 'pure' poetry, which is poetry supposed to depend for its appeal, not on its significance or meaning, but on its sound values, the inherent appeal of the material.

In this general sense, the term *abstract art* would seem to be definite enough. But certain sophists have arisen to point out that since all art, except the photographic, departs in

some measure from exact representation, therefore all art is *more or less* abstracted or removed from reality, and that therefore we have no right to regard this particular phase of modern art as peculiarly abstract. In fact, in so far as such art is a pure creation of the mind, without reference to external objects, it is not 'abstracted' at all from an original object, and therefore cannot be called abstract.

Some artists, accepting this argument, have invented other phrases, such as 'non-figurative' and 'concrete'; even *Axis*, in its Prospectus, puts the word 'abstract' between guilty quotation marks. Non-figurative may sometimes be justified for the sake of clarity, but it has the disadvantage of being merely a negative term. 'Concrete' has more to be said for it, since, as Jean Hélion has pointed out, this 'abstract' art is really the most concrete of all arts, relying (like pure poetry) on the immediate appeal of the materials (definite dimensions of canvas, oil, etc.).

I feel that to add this term 'concrete' to the many already existing terms would only add to the confusion. Nor do I think its use is really justified by the facts. Hélion's observations are perfectly just, but in the same way that all art is *more or less* abstract, so is all art *more or less* concrete, depending for part of its appeal on the immediate qualities of the materials.

The objection to the use of 'abstraction' for the type of art we are discussing is, as I have implied, mere sophistry. For practical criticism, the only distinction we need is between a geometrical art which retains some relation with the appearance of natural objects, and a geometrical art which is entirely contained within the relationships of forms, colours, lines and surfaces, without any suggestion of natural objects. For the first type *cubism*, *cubist* are at once the historical and logically sufficient terms; for the second type *abstraction*, *abstract* are logically sufficient, and are and can be used without any confusion of meaning. No naturalist painter has any necessity to call his method of painting 'abstract.'

Abstract has a cousinship with the term 'absolute,' and both terms suggest a surplus of intellectual values which exist in abstract painting, and for this reason alone I feel that the term 'abstract' is fully justified.

It may be objected that a type of modern art exists which has no relation with *natural* forms or objects, but which is nevertheless not an affair of geometry, of proportions, colour harmonies, etc. It is represented by certain phases of Picasso, by Arp, Miró and Max Ernst. But for this type of art we have the accommodating term super-realism (*surréalisme* — but not the bastard word 'surrealism,' which is neither French nor English). I mean no disrespect to Superrealism, but obviously a type of art which claims to

53

break down the barriers between the conscious and the unconscious, which uses both conscious and unconscious symbolism, can be made the foster-mother of many *enfants terribles*.

['Our terminology,' *Axis 1* January 1935, pp 6–8]

Geoffrey Grigson

Abstract art, as an idiom or pure method, would be art drawing away to order, instead of advancing to order. It would order by leaving out, by negation, instead of by controlling and altering what exists, and creating it a second time until it becomes what has never existed. It would reduce to as little as one can imagine inside the definition of art the intellective and the effective elements; it would reduce them to an intellective type, to 'art itself'. It would make, indeed some artists now tend to make, all pictures consist of the islanded principles of pictorial art, instead of conforming to these principles, which are the facts of order (regularity, rhythm, symmetry and broken symmetry) and the fact of emotion; of which the former opposed as a comfort against the half-known caves of the mind, is made the more powerful.

Abstract art, then, is not the seed to grow from, but the first floor to build upon. Impressionism, extended, would have meant the supersession of art by life, so Wyndham Lewis declared; purism, 'abstraction-creation,' extended would mean the supersession of art by ideal death. In his 'Elements of Folk Psychology' Wilhelm Wundt describes the way in which the Bakairi of Central Brazil make simple geometrical designs on wood, affective through symmetry and rhythm, and how then they read into these designs 'through imaginative association, the memory images of objects' – snakes, swarms of bees, etc. In these geometrical patterns so interpreted he finds the beginning of formative art. Abstract art at this time needs (but actually and not only in fancy) to be bodied out in such a way; to be penetrated and possessed by a more varied affective and intellectual content. Only so can it answer to the ideological and emotional complexity of the needs of human beings with their enlarged knowledge of the widened country of self.

Certain artists have realised this in their practice; abroad Picasso, Brancusi, Klee, Miró, Hélion; in England Wyndham Lewis and Henry Moore. Abstractions are of two kinds, geometric, the abstractions which lead to the inevitable death; and biomorphic. The biomorphic abstractions are the beginning of the next central phase in the progress of art. They exist between Mondrian and Dali, between idea and emotion, between matter and mind, matter and life. 'In art we are in a sense playing at being what we designate as

matter. We are entering the forms of the mighty phenomena around us, and seeing how near we can get to being a river or a star, without actually *becoming* that. Or we are placing ourselves somewhere behind the contradictions of matter and mind, where an identity . . . may more primitively exist.' This needs to be remembered now in England, if leading English abstractionists are not to turn their backsides to *Minotaure* and run off to Nowhere through the dry spaces of infinity.

Comments upon the need and the action are suggested by the English paintings and pieces of sculpture reproduced in this number of *Axis*. I see in them a small history of English ideas, English hesitancy, English error and English performance, and I would summarise them in this way:

Nash: Pre-abstract naturalism with bits cut away through the force of the present. A degree of order imposed upon material disorder. Pictorial ingredients only half broken down and half re-created. How much of what quality of vision? How much Clive Bell just round the corner?

Wadsworth: Abstraction neither biomorphic nor geometric. Impersonal vehicle carrying not much; but a respectable simplifying and concentrating of a cold curtailed fancy.

Nicholson: Too near to a surface object derived from art, instead of a portion of art. An image of infinity, ordered by saying 'no' rather than 'yes,' which is without body enough to make the image perceptual. Admirable in technical qualities, in taste, in severe self-expurgation, but too much 'art itself,' floating and disinfected.

Jackson: An attempt at moving forward to fullness and complexity. Affirmative at least, however much it seems done by way of trial out of Nicholson.

Piper: Domela somewhat vivified. An attempt at advance in biomorphic abstraction, though irresolute here and there in form.

Moore: Product of the multiform inventive artist, abstraction-surrealism nearly in control; of a constructor of images between the conscious and the unconscious and between what we perceive and what we project emotionally into the objects of our world; of the one English sculptor of large, imaginative power, of which he is almost master; the biomorphist producing viable work, with all the technique he requires.

Hepworth: Product of a sculpture more of the single image

making forms not so enticing by their exact appropriate nature. But she is a viable abstractionist, more constructed and more exclusively (though in quality more slightly) emotional.

Moore and Wyndham Lewis are the only English artists of maturity in control of enough imaginative power to settle themselves actively between the new preraphaelites of *Minotaure* and the unconscious nihilists of extreme geometric abstraction. They are not those accidents in Valéry's phrase, which are so common in England, artists of intuition without intelligence. From Picasso, from these two, from the over-severe Brancusi, the over-confined Paul Klee, from Miró (whose frivolity is only the slightest ingredient of his work), from Hélion, who sees as sharply as any painter the need for a new biomorphic complexity, the practice of painting and sculpture is gaining a new rotundity of purpose and achievement, mortally opposed to the peevish pinched formalism with which art was stifled for so long in England by Roger Fry, Clive Bell and their minute protégés. 'The picture is to be caught by the neck, yes, by the ideas, by the lines, by everything and more. For the idea of element, brought too much forward, must be substituted the idea of plurality. For the idea of machine, must be substituted the idea of being. There is a point where ethics, esthetic, lyrism, reason all meet and become one thing. That point, the picture.' Those words are Hélion's; and these come from Wyndham Lewis, writing fifteen years ago: 'The important thing is that the individual should be born a painter. Once he is that, it appears to me that the latitude he may consider his is almost without limit. Such powerful specialised senses as he must have are not likely to be overridden by anything.' Here in England the senses of the artist and the interpreter have too long been overridden — overridden by etiolated cliquish amateurism, by the delicate, affected, sly nodding of Bell-flowers, ringing their self-peals over and over again. This Home-bred formalism is now as dead as Mr Duncan Grant. English artists must replace it by no incapable tyranny of geometric and mechanical idealism, no permanent escape to the divided rectangle and the spokeless wheel.
['Comment on England', *Axis 1* January 1935, pp 8–10]

S John Woods

These two exhibitions introduced to England for the first time the abstract painting and sculpture of such artists as Mondrian, Hélion and Alexander Calder. Previously a certain amount had been written about abstract art; such exhibitions as the 7 and 5 showed what was being done in England, but, for the general public, a comprehensive survey had never been possible. The Duncan Miller exhibition was designed to illustrate how close an allegiance exists between abstract art and contemporary architecture and interior decoration, while emphasis was laid on the fact that abstract art is more than just decoration. Too many people regard abstract pictures merely as pretty furniture, as nice, gay little things to hang on the wall, but, as far as *art* is concerned, wholly unworthy of attention. They seldom have the slightest idea what abstract artists are aiming at or even what abstract art is.

In an exhibition in 1921 [The Constructivist Exhibition, Moscow] there were paintings wholly in one colour; a plain coloured surface, rectangular or square in shape, hung on a wall. To most people this seemed completely absurd and meaningless. But it was not meaningless. If you hang a plain white square of canvas on the wall you have a relationship, in terms of colour and shape, which exists and has certain definite qualities. If instead of the square canvas, you hang a vertical thin rectangular one, the relationship of the canvas to the wall, to the ceiling, to you, has changed. Colour it red and it changes again. Draw a black line down the centre, colour one half red and the other blue and again it has changed. The white canvas is the starting point for the artist just as a church wall was the starting point for Giotto; and just as the church wall meant something before it was painted so does the canvas. The whole affair is so simple and our attitude to art so complex that this question is unnecessarily difficult. The plain white canvas is not a work of art comparable to a Poussin — obviously — but materially it is of the same order.

This is the starting-point for abstract art. The artist concerns himself with flat colours and shapes varying from severe simplicity to any degree of complexity; Mondrian, for instance, takes a canvas, paints a thick black line down its length, another one low across the bottom, and a third parallel to it higher. One of the rectangles he fills with a living intense red, the others vivid white, cut by the glittering black bands; he creates, pictures in which everything is expressed by line and colour and a complete equilibrium is achieved so that only the rectangular planes, formed by the lines crossing at rightangles, remain — 'Comme un rien.'

Canvas, pigment, the material elements of the painting disappear; colour, light, space, remain, attained by intense precision, every portion of the picture in the exactly right relationship to every other. Space, light, precision — these form the keynote to abstract art; precision, because the precise relationship of one shape to its neighbour, of one colour to another, the precise execution of an idea, has always been a part of great art and because in a machine

age precision is doubly accentuated; light, because colour is light and flat colours have superseded modelled forms in the development away from materialism; space, because flat colours automatically recede or advance, exist in space, that is to say, in relation to the spectator.

Parallel movements can be discerned in architecture and interior decoration; experiments with materials, a disentangling of the essential from the superfluous or merely conventional, a search for new improvements and over all an insistence on basic simplicity, clean cut lines and good proportion – a contemporary machine aesthetic – have brought architecture and interior decoration to the point where they speak the same language as painting and sculpture; all have dematerialised, desentimentalised, debunked and generally cleansed and purified themselves; all deal with the same basic problems, problems of the twentieth century; they take the fundamental qualities of our machine-made environment and with them build new worlds of a new spirit.

If a person is of this world in more than the immediate physical sense, if he is aware and appreciative of the spirit which is flowing beneath its physical manifestations in the form of aeroplanes, cars, streamlining, concrete and glass houses, he will probably hang abstract pictures on his walls. But the reason is not that abstract pictures are necessarily better pictures than pictures of cabbages, nor necessarily better decoration. The reason is that he feels abstract pictures to be springing from the same source as the architecture and decoration of today. The basic stuff of art is more or less constant; the platter on which the dish is served and the dressing used to garnish it, are determined by environment and consist of the fundamentals of any given era. Cabbages and landscapes have less importance for us today than they had for our grandfathers; crucifixions and Madonnas are less important in the twentieth century than they were in the first twelve or thirteen centuries. Consequently to hang a cabbage or a crucifixion on the wall, is, in a sense, non-contemporary. We are not all in this sense, 'contemporary' – the fact is obvious – nor are contemporary art and the contemporary world necessarily better, in an absolute sense, than the worlds of cabbages and crucifixions. But in so far as they are contemporary and deal with problems arising out of the present and violently affecting it, they are of interest to all those concerned with contemporary living. Which is why abstract art is important here and now, why it should be given its due by everyone with intelligence, why it has particular affinities with contemporary architecture and interior decoration.

['Are these the pictures for modern rooms?' The Studio Vol CXI no 519, June 1936, pp 331–332]

Myfanwy Evans

. . .To-day all these pictures involve one in more than aesthetic reaction, in more than untroubled pleasure at their existence. They stand for different religions, for different living. And it is clear that all that is called abstract art, or surrealist art, cannot be included in these two nutshells. We have only to recall the Abstract-Concrete exhibition. Where does Miró belong? Moore? Calder? Hélion, even? And what about Gabo and Moholy-Nagy, apparently belonging clearly to the group first described? Are they really after the same thing? We are lost amongst individuals whose works protest at classification. A history of the 'isms' of the twentieth century is a useful, even an essential work. It clarifies and sorts out on paper, but with such inexhaustible accuracy that the living picture comes to have no meaning at all within its class. In art facts, however impartially presented, can never be a substitute for a gradual comprehension, the personal shifting of understanding and emphasis, until things fall into some kind of order, but one of real vitality. (Just as a week of continuous electric light does not give the same impulse to value and revalue as the continuing change from night to day.)

But to return to the Abstract-Concrete show – and the one at Duncan Miller's, and the two mixed shows at Newcastle and Leicester (both with abstract sections), the Surrealist show now on, the Picasso show now on and the new art paper, Telehor – there is and has been during the past month or so a bewildering amount of data. But it has become increasingly clear to me that it is possible to make one or two distinctions, positive for Axis now – tentative for the future. The first is that both abstract and surrealist artists, or those claimed by both, can be divided into those who are primarily interested in the art of painting or the art of sculpture, and those to whom it is of secondary interest. That is to say, they use it as a means to an end which is not a painting or a sculpture end. The second is that even leaving aside the surrealist end for the moment those ends are not all the same. Amongst abstract artists there is something which definitely links Mondrian, Nicholson, Moholy-Nagy, Gabo, and Hepworth – and probably Domela and Erni (this is not an inclusive, merely a familiar list). It is a streamlining sense. A sense of precision, light and clarity. In the end a movement towards some fixed goal. In the belief in and the desire for progress of one kind or another these artists are linked almost as one group – the 'pure abstractionists.' But again there seems a definite distinction. Moholy-Nagy and Gabo are after something more tangible. They are artists who are concerned with the possibilities of new materials and processes. They want to use and exploit all the inventions of

the last fifty years. Gabo wants to build with space and to create a new art out of the finds of industry: an art which will express *public* needs by some other means than the bronze statue. Moholy-Nagy wants to build with light: to make light-displays controlled into formal beauty, but not by the formal standards of painting. His painting – he says in *Telehor* – is a makeshift, until he can find the capital and co-operation to create his new plastic art. He uses it as far as possible to clarify and explore these special ends, using metals instead of canvases as a background to the play of light and shadow. They are both artists of a new world, biding their time amongst old-fashioned standards; unable to undertake their work except in miniature, even for their own pleasure. Very different demands and beliefs from those of the painter. With the other, pure abstractionists it is different. Theirs is a spiritual, not a material, demand – they do not want scope and apparatus, they want Utopia, an embodied faith. There is in their whole attitude to painting and sculpture a passionate belief in the power for good of pure abstract work. Pure colours, clear, brilliant contrasts or the delicate clarity of one pale line against another, the absence of human and earthly associations, all means to them a positive step to perfection – perhaps a piece of perfection itself. Not towards a brave new world where applied science baffles the spirit, but towards a world of light where the idea of goodness, progress and perfection is given validity through a communal life of the abstinence that means true liberty. Each step in painting or sculpture is not the solving of a personal problem, but one more piece of evidence in the new order.

. . . The battle has been pitched between abstract painting and sculpture and surrealist painting and sculpture; but there it cannot flourish. It is a silly battle. There are too many painters who do not paint in the name of either (though they have been claimed by one of the two, or by both). Painters who were distinguished early in the article as primarily interested in painting. Their surrealism is incidental, their abstraction a sign of life, not sterility. When I look at Miró's work I am not swept into a labyrinthine description of subconscious urges, nor am I conveyed 'a thousand miles or back to my childhood' – I am bound irresistibly to the present. It is this moment of existence that I am experiencing *here*. Picasso, Arp, Giacometti, Moore, Hélion, Hartung, Piper, Jackson and Holding do not bear censers for either religion, they reserve the right to alter according to their inclination and nature, and not according to a group-programme. So I, when I admire the work of Ernst or of Nicholson, Hepworth or Mondrian, admire it for itself – not as an act of faith or a commitment to a line of behaviour.
['Order, order!', *Axis* 6 summer 1936, pp 4–8]

S John Woods

It is perhaps a sign of decadence when a part is taken for the whole it helps to form. It may arise from too intimate an awareness of the whole – it is, I suppose conceivable, that on contemplating one's navel for a long enough period one might forget all else and project the universe into one's navel crying 'This is my all' – it may on the other hand arise from fear.

Since art left service and, enthroned in a studio, invested itself with a capital A, parts have flourished at the expense of the whole. The Impressionists regarded their navels, in this case the reactions to nature of their own eyes, and could see nothing else. It was the same with every movement since Impressionism, until at the present time, two navels divide the spectators into two: the abstract and the surrealist. The abstract artist reviles Clive Bell but nevertheless allows no element but significant form; the surrealist places the navel in the subconscious and refutes everything else, including significant form. Each group knows very definitely what it does *not* want; neither is completely sure what it does want. In both attitudes there seems to lie more than a hint of fear; fear to face up to things, fear to widen the vision in case the light might go out altogether.

This is apparent not only in these and other movements but in individual artists. The tendency during the whole of this century has been to select a scheme and never to venture beyond its precincts; Mondrian chooses rectangles and limits his colours to red, blue, yellow and grey; Nicholson chooses circles and rectangles and white or delicate shades of colour; from a different approach Chirico chooses horses, biscuits and the long shadows of late afternoon. The outstanding exception is Picasso who has moved his navel about, like a king of draughts, covering every side of the contemporary board and creating new sides.

The most important movement this century, the Cubist, was perhaps the least limited, the least frightened, but as a movement it contained a dichotomy between concrete objects and abstract shapes, which had to be removed. In removing it, the largeness of Cubism went and for some twenty years such artists as Malevich, Lissitzky, Moholy-Nagy, the de Stijl group, Mondrian and Nicholson, to mention the leaders in different countries in successive periods, worked within greater limits than Cubism knew. Barr in 'Cubist and Abstract Art' cites the theory of Dr Schapiro concerning the iconography of Cubism, its interest in guitars, wineglasses and other symbols of the life of an 'artist' which ' suggest a concern with art instead of the world of life and may consequently be taken as a symbol of the modern artists' social maladjustment.' The concern of

57

the abstract artists mentioned above has been with light, as has been shown elsewhere. In connection with this it is interesting to note that Catlin, writing recently in the Sunday Times, mentioned the distinction between art 'occupied with the inner contests of man's soul or with the deeper thrust of the social forces that pound into shape what he calls his purposes.' I quote this because it seems at the same time to draw a distinction neatly and also to illustrate a distinction in itself something of a limit. Clearly great art combines the two elements: Piero della Francesca had not only a spiritual place but a social one; the Malevich to Nicholson line of abstract art is much more a sign of the social forces, of the new potentialities of light, space and precision let loose in the world by technics.

Now this is not a censure; it was very necessary for abstract art, in the beginning, to force itself on the world in a narrow jet of unmitigated strength; any new doctrine, to make itself felt, must contain a high percentage of dogma. But we have had our fill both of dogma and of doctrine. They have succeeded in their purpose. They have carried art from a limpid concern with the world of natural phenomena into a completely new world, unconcerned with natural phenomena and unconcerned with abstractions from organic forms. It has been pointed out again and again that every great work of art is to a degree an abstraction from natural phenomena — an argument which has been used to show that abstract art is the same as any other form of art. But the whole point of abstract art is that it does not abstract from anything, it deals with its own intrinsic elements. If, then, the dissatisfaction I have expressed with the onesidedness of the simple geometric art of Malevich to Nicholson is a just one, does anything remain over and above organic abstraction? In the recent English International Exhibition of Abstract Art, Moore and Miró, and less immediately Giacometti, revealed themselves as artists dealing with organic abstractions and therefore, although artists ranking high among contemporaries, as out of place in a show of 'abstract' art. Kandinsky was badly represented by pictures which were abstractions less organic than zoomorphic. His work as a whole is particularly personal (although the first completely abstract painter he has never produced a school) and he combines expressionistic qualities with a Russian feeling which seeps through all his paintings. Moholy-Nagy, Mondrian, Gabo, Domela, Hepworth and Nicholson fall into the simple geometric class which I have already spoken of. What remains? Works by Erni, Hélion, Holding, Jackson, Piper. Erni, Holding and Jackson retain, at the moment, geometry but seem to be trying to expand its simplicity to admit of wider experience.

But it was the paintings of Hélion and Piper that I found of particular interest. Hélion is dissatisfied with pure abstract art: against the work of Poussin it stands no chance, he desires greater developments, his pictures must have a space in which his elements can move, develop, not only forwards and backwards and from side to side but round, spinning on their own axes or encircling each other, creating a unity in space and of space, chunks of space and chunks of non-space opposed. The one criticism I wish to make is directed against the modelling. This does not seem completely successful; whether the fault lies in the modelling itself or in Hélion's use of it I do not know. He may resolve it and use it successfully or he may lose it in resolving it. We must wait to see. Predictions are impossible.

The other artist, John Piper, values paint before his label. In looking at Constable I feel 'Here is a man who is painting' not 'Here is a man who is painting landscapes'. Not so with abstract artists. Simple geometrical abstract art, as Moholy-Nagy has convincingly shown in countless articles and his book 'New Vision' and as Nicholson has shown in his reliefs, is concerned rather with light than with paint. Piper has returned paint to abstract painting and in doing so has laid his finger on a crucial spot.

It is time we forgot Art and Abstract, time the 'movement' ceased and manifestos were burned, time we cut out beards, ceased to be artists and became men and painters. Art has chased out life and now life must come back if art is to remain. The Greek view of man as body, mind and spirit remembered that the last existed in the first and could not, in this world at any rate, exist without it. To-day there is a tendency among artists to forget the body and remember only the spirit. The bed, the pub, the tube train, the lavatory and all, are a part of the contemporary man. If an artist is not first a man his art will never be great. I do not want a return to representational art, to pictures of the physical facts of life and our senses; I believe that abstract art can rise above these and possibly above even the art that transcended these in abstracting from them. But I do want to see artists *live*, being susceptible to change, forgetting doctrines, and all the aesthetic chattels and restrictions which clutter abstract art in England at the moment. Living implies change, something dynamic, something which breaks a rule if it is necessary and transcends rules in any case. Out of living comes a live art, something with guts, which doesn't give a damn for anybody and which may stand alongside the art of the great periods.

['Time to forget ourselves', Axis 6 summer 1936, pp 19–21]

John Piper

Any Constable, any Blake, any Turner has something an abstract or a surrealist painting cannot have. Hence, partly, the artist's pique about them now, and his terror of the National Gallery. The point is fullness, completeness: the abstract qualities of all good painting together with the symbolism (at least) of life itself. To-day, both cannot go together. Abstraction and surrealism can choose, but they do not choose both. They can build, and be filled with an ambition for future life, but hardly can express a fullness of present life. Constructivism is building for the future — and so far an escape into the future. The Royal Academy, a hesitation in the past . . .
['England's climate', *Axis* 7 autumn 1936, p 5]

Naum Gabo

The word 'Constructivism', as most of the other 'isms', was invented not by the artists themselves, but was given to their work by critics and theorists. The constructivist has accepted this word and enfranchised it, because it refers to the constructive idea, which forms the basis of his belief. Constructive ideas in general are not rare in the history of ideas; they accompany every creative urge of human development. They always appear on the borderline of two consecutive epochs at the moment when the human spirit, having destroyed the old, demands the creation and assertion of the new. All great epochs have always depended on one leading constructive idea. It has always given the art of the time a social power and ability to rule and direct the spirit of its age.

The art of our own generation was born on such a borderline; it was born on the ruins of all previous artistic traditions. The revolution in art which took place at the beginning of this century proved that it is impossible to impose on a new epoch the artistic forms and aesthetic ideas of the old, and that it is impossible to build up a new creative art upon the caprice or temporary moods of the individual artist. In order to do this it is necessary to have new, stable principles and new constructive elements; these principles must be closely bound up with the social and psychological spirit of our epoch and they ought to be sought for not externally, but in the realm of plastic art itself. We have not had far to go to find these elements. In an article in *The Listener* of July 29 on 'Reason and Imagination in Art', Mr Roger Hinks observed that 'the whole European tradition in the plastic arts consists in the affirmation of the Greek Humanist ideal, either explicitly (as by the Romans and in the Renaissance) or implicitly (as in the Middle Ages)'.

It does not seem to me, however, that this is the only possible characteristic trend of European plastic art. I do not think that European art can be considered as a whole; there is more difference between the art of the Middle Ages and the art of Rome and the Renaissance than the difference between statement and implication of the same tradition. The art of all great epochs, old and new, has its own defined traditions, and yet they still hold for us such elements as continue to affect us even when their content has lost its meaning and importance. Where lies the cause of this power? It cannot lie in the human features of the Greek God in whom we do not believe, or in the image of the Scythian lion, the myth of which has lost its significance, or in the lovely form of the Madonna, or in the torso of Venus. The value of such images is relative, unsteady and disputable. It is the lines themselves with their rhythms, it is the colours with their tones of light and shade, it is the sizes and shapes with their order in space, their scale and their relations to each other, it is these elements which keep these creations effective and still alive for us and which form the substance of art through the ages. Having realised this fundamental truth all the constructivist has to do is to deliver these vital and independent elements from all their outlived and temporary images and by freeing them to convey the spirit and impulses of our own time.

In the painting of the cubists such as Picasso and Braque we see already manifestations of such an attempt, but this attempt has been made gropingly in the dark: on the one hand their desire to destroy the old prevailed over their desire to create the new, and on the other hand in attempting to create the new they could not free themselves from the external forms of Nature. The constructivist has renounced the representation of natural forms as he is convinced that the external aspect of Nature does not enable us sufficiently to penetrate its hidden depths; this external aspect of Nature represents only the superficial part, the skin of its immense body; it only conforms to the obvious and petty side of our impulses and is not qualified to manifest the most essential and vital subsistence. To be able to illuminate this hidden entity through the medium of plastic art our generation needs other aspects, other imaginative elements and other plastic means. It is obvious that the vocation of the art of our epoch is not to reproduce Nature but to create and enrich it, to direct, harmonise and stimulate the spirit to the creative attainments of our time. Other creative spheres of the human spirit already have this character. Music, for instance, was always free from the obligation or even temptation to reproduce Nature. Nature does not know musical notes just as it does not know multiplication tables and geometry. All these are methods artificially constructed

by man for the manifestation of his knowledge and his creative will. As a quality of the plastic element of our constructive art we have chosen the elementary, accurate and primary shapes long ago handed over to us by psychological experience as symbols of a perfected plastic expression. These elementary shapes are universal and available to our general human psychology. In general, there cannot be different opinions as to the psychological effect on a man of a circle or a square or a straight line or a hyperbolic curve, just as there cannot be different opinions as to the psychological effect of the tonic sol-fa in music. Their purely psychological reactions are constant and stable. In spite of their economy and simplicity they contain an unlimited scope for composition. Any proof becomes unnecessary if we realise that music with its richness and variety is based upon seven fundamental notes. Similarly in the plastic arts we consider these elementary forms not as the sole purpose; we constructive artists do not worship any of them taken separately. They are for us only means and material, and it is in their totality and mutual rhythmic connection that the value and vital sense of these forms are to be found. The main and only theme of our works is our inner impulses. We follow the vocation of these impulses to manifest the harmony and rhythm of that very current which links the human existence to the universe, and which is the source and nourishment of all human creations.

We are aware that the desire to reproduce the forms of Nature will remain for many generations of artists, but this does not affect us in our striving to manifest the new impulses of that future which is already rooted in our time, in the same way as the continued existence of railroads does not affect the desire of a pilot to fly.

The general public is not to be blamed if when looking at our works it does not find immediate contact with them – nor are our works to be blamed for it; the cause lies in the educated habit of searching in a work of plastic art for the familiar forms of Nature and for the literal sense of well-known every-day emotions. As soon as the public tries to approach our work without this prejudice and considers them as pure plastic objects, the contact will be easily established. Our works are not to be understood, they are to be felt. When we look at the reproduction of Barbara Hepworth's 'Carving in Wood' for instance, and compare it with the head of the Hermes of Praxiteles, which was reproduced in Mr Hinks' article, we see that the majestic quietness and static harmony of the equilibrated proportion of the shapes of one of them constitutes the only theme of the other. In its plastic content it is more akin to the other than any attempt to imitate the external features of the Greek statue. And also in the other plastic works reproduced here

there is no other content to look for than in the pure plastic composition. The rhythm of the lines, the spatial order of the shapes and imaginary volumes, the tension of the latent motion hidden in their visual equilibrium, are the main substance of these plastics. The column, for instance, is a plastic construction in which the sculptural and architectural elements are fused to form a synthesis of both artistic disciplines in space. This plastic could be considered as absolute architecture, being free from the usual function of a building but consisting of elements which anticipate the spatial relations of the architecture of the future. On the other hand, it could be called absolute sculpture, being a pure composition of the volumes and shapes which characterise every monumental sculpture of the past, such as the Egyptian sphinx and obelisks. We do not limit the content of our works to closed geometrical figures only. We leave it to the creative intuition of every individual artist to open these figures and vitalise them. The main consideration remains that every line and every shape which composes the work should strive to approach the exactitude and perfection of these primary elements.

Our works are often blamed for being contemplations of machinery; it is said that they imitate the forms of machines. This criticism is based upon misunderstanding. We have not freed ourselves from representing forms of Nature so as to imitate other forms. We admire the forms of machines, when they are functional, as we still admire the beautiful forms of a real landscape, but we are far away from contemplating either, or from using them as themes. If in technical objects shapes occur which are similar in appearance to the shapes of our plastic elements, that has actually no real connection with the spiritual content of our work. We do not think that the plastic content of a constructive monument for the Institute of Physics and Mathematics is any further from the ideas for which such a building was intended to serve than a naturalistic design with its usual attributes.

Some theorists of art often denounce the content of our art as being too rational, and state that we neglect the power and value of imagination and free phantasy, that our works lack the mythical element; other theorists, such as Mr Roger Hinks, blame us for the opposite and consider that we are only concerned with idle phantasies, and are deliberately intent upon creating the myth of our epoch, which is as they state a fruitless task, since they are convinced that the myth of our age is already realised and manifested in the rational spirit of science. We do not know how to justify ourselves with both sides without offending one or the other; perhaps they may be satisfied if we acknowledge the guilt on both sides openly and fearlessly. We will give them still more

satisfaction by admitting yet a third accusation which they do not even suspect. We admit that we do not know what 'reason' is, what 'myth' is, where free fancy begins, and where knowledge ends, and we are doubtful whether our accusers know this themselves. Modern science at any rate does not give us a definite answer to this question. We hear from modern scientists only that our knowledge is petty and hazy, and if we do know anything definite it is that we know practically nothing; but we think that to know so much means that we know a little more than those who pretend to know more than science does. As to what concerns our art we are sure that we are related by blood and spirit to the coming epoch; we have a definite, creative desire to take part in the construction of this epoch. The aim of our time consists in creating a harmonious human being, and we strive in our works to educate the spirit in this direction. ['Constructive art', The Listener Vol XVI no 408, 4 November 1936, pp 846–848]

J M Richards

The room at the Lefevre Galleries in which Ben Nicholson's carved reliefs are hung has, round the ceiling, the customary cornice of its period: a series of recessed planes in white plaster, geometrical in character and carefully considered in their proportions to produce an agreeable effect of light and shade. Its juxtaposition with the artist's carved reliefs suggests an obvious comparison to the mind of the observant visitor; and, so far as appreciation of his art among the public is concerned — that is to say, appreciation beyond the circle of his fellow-painters — that compariosn and all that it implies provides an example of one danger that threatens the present stage of Ben Nicholson's — and other artists' — abstract development.

The public, always searching for a label to apply — for a comforting explanation of what it does not understand, or does not wish to — will no doubt recognise in these carvings an affinity with the superficial appearances of modern architecture and, having thus satisfactorily disposed of them will turn away from them with relief, and Ben Nicholson's latest work will be relegated for ever to the same class as the plaster cornice and the marble mantelpiece — spots of decorative relief work how charmingly in keeping with the modern interior. Ben Nicholson's reliefs *have* an affinity with modern architecture; that is a test of their vitality, as it is of the vitality of any art; purely through a community of feeling and a similar concern for formal significance: they are both manifestations of the same abstract aesthetic; but his reliefs are emphatically also carvings on their own account.

No doubt in time, when each, the architect and the painter, has reached some kind of finality, the two can come together in synthesis, the one as complement to the other; but meanwhile, during this period of transition, the distinction made above is all-important. The architect has returned, inspired by Behrens and Corbusier, to the reality of his means and materials; the artist, Ben Nicholson, has returned in his present phase, inspired by Mondrian, to the reality of his, not the architect's, limitations: the rectangular frame, the panel, the personally-conducted tool. With these Ben Nicholson is exploring the potentialities of light on differentiated surfaces, and, as a necessary discipline on the road to absolute release from organic association, he has set himself additional limitations: the rectangle and the circle as his entire formal vocabulary; white and the play of light on white as his only colours.

It is unfortunate that this particular advance on the part of the artist (for there is no doubt that a great advance has been made from the earlier exploitation of his own sensitivity to colours and surfaces) should expose him even more to this 'decorative' misinterpretation — in many ways more insidious than mere abuse. It is not likely that Ben Nicholson will succumb to such an implied invitation to suicide; but we can now be said to possess a school of abstract artists, as the Seven and Five exhibition shows, of which Ben Nicholson is only the member of most experience, and this fundamental danger besets the whole of abstract art while in the process of establishing itself — danger of its formal significance becoming lost in its own decorative potentialities That is the excuse for using Ben Nicholson's present purist phase as an apt illustration of a universal fact — and for labouring at length so obvious a point.

The tension, concentration, personal vision — call it what you will, that distinguishes creation from pattern-making is so fundamental that the two are different in kind, not in degree of achievement. If Ben Nicholson, to return again to the Lefevre to find an apt, though improbable illustration, were once to lose that vital concentration, to allow his abstractions to stray towards becoming a unit in architectural decoration, then no qualities of craftsmanship, no emphasis on the fact that each relief was carved by hand out of a single board (which, we are told, is the method adopted in preference to the obvious architectural-decorative one of built-up layers), no emphasis on the amount of satisfaction the artist obtained from the feat of execution would bring his work to life again. For these are matters for the artist and no-one else; what is important is the exploration that is going on: in the case of Ben Nicholson, at the moment, exploration with light on an engraved surface, perhaps next more exclusively with light, 61

or with three dimensional form; in the case of others with other materials. Only the curiosity that maintains this exploration will allow abstract art to make its necessary contribution to the whole body of the contemporary aesthetic, such as the social responsibilities of the artist demand of him — responsibilities beyond the mere 'self-expression' that flatters his own sensitivity.

For the former purpose a group of artists working all with the same intentions is essential, and the Seven and Five Society for the first time provides it. It may be said indeed to be the only group now exhibiting one consistent point of view. The quality of the exhibition is mixed, as it is bound to be with a number of members at different stages of development. The characteristics of abstract art, as well as those of Ben Nicholson's art, are already familiar to readers of this paper. There is no need for me to describe them. A few special observations on the abstract artist's position I have already made; these apply to other members if to Ben Nicholson particularly . . .

['Ben Nicholson at the Lefevre: 7&5 at Zwemmers', *Axis 4* November 1935, pp 21–24]

Herbert Read

Mr Ben Nicholson's exhibition at Messrs Reid and Lefevre's Gallery comes as a direct challenge to the disenchantment expressed by Mr Kenneth Clark in last week's *Listener*. For Ben Nicholson's paintings are an extreme example of that type of abstract art which Mr Clark says has 'the fatal defect of purity'. I do not think Mr Clark would dispute my opinion that Mr Nicholson is the most important painter of the modern 'abstract' school now working in England, and that with Henry Moore he may be fitly held to represent our contribution to the movement which includes Picasso, Braque, Léger, Hélion and Brancusi, to mention a few significant names. We may, therefore, take his work as a test case for considering the value of this movement and its relevance to the future of painting.

Let me describe as simply as I can what I think Nicholson is trying to do; if I fail it will not be for lack of observation, for I am a friend and close neighbour of the painter and have had plenty of opportunity to watch his development and discuss his work with him at frequent intervals.

That development, though it shows some sudden leaps, has been continuous. Beginning as an artist concerned, like any other impressionist, with an objective relationship to the world around — controlled and refreshed by natural appearances, as Mr Clark would say — he gradually became more and more absorbed in the purely formal relations of planes, shapes and colours, until finally all

contact with the world of appearances was lost. In his latest phase, represented by the works reproduced here, he has excluded even colour, being satisfied with the inexhaustible subtleties of whites and greys, and their harmonics in relation to areas, outlines and depths. These later works are not so much paintings as reliefs, carved with hammer and chisel out of woods like walnut and mahogany, and then painted white.

According to Mr Clark, Mr Nicholson has now contracted spiritual beri-beri and is about to die of exhaustion. The image does not agree with the actuality — an artist for whom the day is never long enough, whose fertile mind creates with a tireless energy and enthusiasm, an artist who has unfailing confidence in his craft and in the aim for which he works with such unflagging zeal. Mr Clark's article, perhaps unwittingly, gives the impression that these modern artists are a weary and dispirited lot: actually they are genial fanatics, supremely happy in their work and optimistic about their future.

The first question to answer is this: How does such *abstract* art connect up with contemporary social realities?

Let me begin by qualifying the word 'abstract'. It is responsible for a good deal of the prevalent misunderstanding of the movement. In this context the word only indicates that such art has renounced any intention of reproducing in any degree *the natural appearances of phenomena.*

And thereby, say its critics, it has lost all contact with reality and with society.

But these critics, and Mr Clark is among them, confuse two very different things: reality and realism. Art, they say, cannot safely depart from nature. But what do they mean by nature? Actually, a philosophical question is involved. Nature is either an aggregate of facts — the sum of all organic things; or it is the principle of life which animates these things. If we think of nature in the first, and what we may call the objective, sense, and consider the function of art in relation to such a conception of nature, then we can conceive art only as reproducing in some way the specific facts. That is, indeed, the kind of relation between art and nature which most people seem to want; but they should realise that what they thus get is not the reality, but merely the appearances of nature. If, on the other hand, we take the subjective conception of nature, and then ask the artist to express this conception in the materials of his craft, he will not imitate the specific appearances of nature, but, taking the sense he has of the underlying spirit, he will try to create works which embody this spirit in their form and colour. These works will have a kind of cousinship with the phenomena of nature, but, being moulded not by sun and

soil and all the elements which determine the specific forms of natural organisms, but rather by the senses of the artist reacting to a plastic material, they will have an original appearance reflecting nothing but the reality experienced by the individual. If such individuals lived in cells apart, without any communication or mutual influence, their works would be practically incomprehensible to other people. But, living in societies which mould the individual to a cultural pattern, the chances are that each artist's work will enter into a certain community of feeling and imagination. When that community exists, communication of the artist's experience and emotion takes place. There is no other basis of communication.

Whilst I consider that the most general and most accessible of these intimations of reality are of the organic type, and intimately linked to the essential forms of life, there are other aspects of reality of a more mathematical and crystalline nature which may equally form the basis of the artist's creations. Perhaps Ben Nicholson's intuitions tend in this direction; whilst Henry Moore's, for example, are more obviously organic. But it would be a mistake to make any hard and fast distinction, because the reality is a unity, of which organic and inorganic forms are but polar aspects.

Ben Nicholson who, like all the great artists of the past, is something of a mystic, believes that there is a reality underlying appearances, and that it is his business, by giving material form to his intuition of it, to express the essential nature of this reality. He does not draw that intuition of reality out of a vacuum, but out of a mind attuned to the specific forms of nature — a mind which has stored within it a full awareness of the proportions and harmonies inherent in all natural phenomena, in the universe itself.

I must once more refer to the analogy of music, which cannot be shirked in this connection. There is absolutely no reason in the world why the visual intuitions of an abstract painter should not have every bit as much value as the aural intuitions of the equally abstract musician (and in this sense all great music is abstract). The analogy of architecture is even more to the point, but in this case there is a functional aspect which introduces a certain complication.

Admittedly such an abstract art cannot appeal to everybody; the music of Bach does not appeal to everybody, but we do not therefore deny its social relevance. We can say, of course, that in the secular culture of today Bach's music has lost its real social significance, which was originally religious. But that is tiresome casuistry. Bach's music is socially relevant because it is universally enjoyed among people sensitive to music.

It may be objected that even so the whole process of appreciation, music included, is limited to a small and insignificant number of people — 'little dissenting sects', as Mr Clark calls them. But when, in the whole of history, has the finest culture of a period been, *at the time of its first creation*, anything but the affair of a small minority? I do not deny that there is a social problem involved. The complete Marxian would damn Bach as well as Ben Nicholson, and to him there is only one answer. Until we have a new social integrity such as he envisages in his ideal of a classless society, we cannot have a great and popular movement in art; and in this age of transition we must, if we are to indulge our aesthetic sensations at all, indulge them in this relatively dilettante fashion. I insist, however, on the qualification 'relatively'. The art of an abstract painter is not so dilettante in practice as it seems to be in the isolation of a 'one man show'. It is, in fact, intimately linked by sympathy and common understanding to the modern movement in architecture (it is not an accident that Mr Nicholson's brother is a brilliant young architect of the modern school). The modern movement in architecture is in its turn intimately linked to the necessity for a scientific transformation of our cities, our dwellings, the whole structure of our future existence. The connection is seen clearly enough by the architects and painters themselves; time will make it clear to everyone.

Modern art is not yet grandiose, like the art of Greece, of the Middle Ages, and of the Renaissance. But it is genuine, and the only original art possible in our time. The issue, therefore, for Mr Clark and for those who have been moved by his article, is clear: there are good artists today, and there are bad and indifferent artists. Without exception, I would claim, the good artists are in some degree 'abstract' artists, and do not, in the present state of society, feel any compulsion to any other style or content of art. Are we, critics, patrons, lovers of art of every kind, going to give such artists our sympathy and support; or are we going to betray them by adopting an attitude of despair, hopelessness and disgust — a world without art? There is no intermediate position — there is only an auxiliary duty; to work for that change in society which will once more give us a community integrated in spirit and in the pattern of its culture.
['Ben Nicholson and the future of painting', *The Listener* Vol XIV no 352, 9 October 1935, pp 604–5]

Philip Hendy

Eighteen months ago the manager of the furnishing department in London's most expensive store was bewailing to me the difficulty of obtaining white pictures. If only painters would study the needs of the market and abstain from using so much colour! So hygienic has become the

63

taste of our more fashionable decorators that only white pictures can be included in their schemes. For selfish reasons I forbore to suggest that a treatment should be applied to old pictures which is already fashionable with old furniture. Most pictures painted before the sixteenth century were painted over a white ground, and in the sixteenth century at least Venetian pictures had their basic design applied in white lead. If all that the vulgarity and ignorance of these old painters had led them to superimpose were to be removed by chemicals, the loveliest effects of uncontaminated whiteness could be obtained. This method of obtaining white pictures would be ideally suited also to the economic fashion. The supply would never be in danger of equalling the demand, for the already expensive material for such a de-picture would become still more expensive with every one that was made. But the old masters have been saved, or rather they will be allowed to retain their impure coverings. Ben Nicholson is making de-pictures out of new materials.

You cannot, of course, paint perfectly white pictures. That would be too nearly nothing, and our architects and decorators – or better de-decorators – have not been able to arrive yet at absolutely nothing. It takes longer to convince a plutocracy than it does an emperor about its new suit of clothes. Nicholson's de-pictures are geometrical bas-reliefs, in which a small number of rectangles and circles are opposed one to another on slightly different planes. Sometimes, in a more passionate moment, the reliefs are painted grey, or even two shades of grey. But most are covered with monotonous white. Hence the different planes are distinguishable only by the bars of light and shadow along their edges, which are always changing their positions and their quantities with the position of the sun. These moving bars of light and shadow and the quite subtle music in their very simple relation to each other become the main interest, at the expense of the proportions and the inter-relations of the various flat surfaces created directly by the artist. Such simple geometry exercises a certain hypnotic power, but I find it clumsy in comparison with the somewhat similar forms to be found among early Chinese jades, lifeless beside the detail of early Greek marbles or of Doric architecture. These things would have more vitality were they executed in alabaster or some other material of intrinsic beauty. But then Nicholson would have become a sculptor; whereas it is as a painter that he has arrived at this technique. With abstraction always as his goal, the trend of his technical development has been towards the abolition of the third dimension. It is almost impossible to draw the third dimension without suggesting some recognizable form, while it is equally difficult to place one colour beside another without both suggesting the third dimension and rousing some emotional association. In his recent style of painting he had reduced his forms to rectangles or circles whose edges could give no suggestion of the third dimension and his colours to the extreme of coldness and superficiality. Nevertheless, when one looks back at his pictures from the examples of his new technique, his colours do seem to be straining against each other in a field of considerable depth. Their conduct and character seem quite impure beside those of his new white fields. It is an interesting sidelight upon the character of colour that to obtain a further degree of superficiality Nicholson has had to abandon it for carved relief. As a painter he has reached such a pitch of abstraction that he has disappeared altogether. He has deliberately contracted spiritual beri-beri, as Kenneth Clark over the wireless has been accusing all modern artists of attempting to do. As an artist he is still alive, but the new medium to which his courageous and uncompromising logic has brought him is already so pure that it has to be kept in a glass case. The final stage of his art must surely be approaching. The chief interest of his next exhibition will be whether he is able to persuade the Emperor to come.

Nicholson's exhibition at the Lefevre Galleries is over. But the other part of the Great White Sale they have been holding will be open until November 9th. This is nothing less than the greater half of the pictures Utrillo painted during his 'white period'. Utrillo's method is very different from Nicholson's. He shows one in almost every picture whence he first drew his love of white. The stuccoed walls of French surburban streets are the subject of almost every one of these pictures, and in many he has mixed plaster itself into his medium in his need to reproduce their surfaces. The human element is left almost entirely out of the picture, lest it should disturb the quiet drama in the crumbling of the deserted streets. When one sees these pictures one by one in different exhibitions one is more conscious of the sameness of their subjects than when they are all seen together. Now one is impressed rather by all the variations in their composition. If his theme has been mostly the same throughout his life, his variations upon it, even in these five years when the colours are mostly creams and greys set off usually with blues and chocolate browns, are infinite. His lifelong theme once created, he has concentrated, like Nicholson, upon the exploitation of his sensibility. Once one is familiar with their subject, the interest of his paintings lies almost entirely in his exquisite taste. Taste, however, has little vitality of its own. It is nourished from a compound of the intellect and the emotions and relies on them to call it into action. From time to time Utrillo's theme has renewed itself

fundamentally in new design and reinforced expression. But first these moments became increasingly rare, and now for a long time he has ceased to paint. Utrillo, too, has contracted painter's beri-beri. Being, unlike Nicholson, essentially a painter, he is now, as an artist, extinct. But for the same reason his pictures will always live.

I doubt the popular belief that there is insufficient encouragement for artists. I suspect that their future existence is jeopardized rather by the fact that there are so many consciously aesthetic people to-day that any really sensitive painter can paint whatever he wants. Only the very great can survive being able to do just what they like. Most men are kept creative by having to serve some master. Art, for art's sake, is too pure a master for most of us to serve. [Art – the white period', *London Mercury* Vol XXXIII no 193, November 1935, pp 58 – 9]

John Summerson

I have what I believe to be a sound qualification for talking about abstract art: I am not an art critic. My experience of the arts centres round architecture, which may explain why I find abstract art more deeply interesting than most of the products of that vaguely delimited sphere of activity called 'painting'. I mention this because I think anybody who will walk into Ben Nicholson's exhibition at the Lefevre Gallery with a determination to put out of their minds the conventional apparatus of appreciation which they set-going in front of a landscape or a portrait, will find nothing as mysterious or eccentric as abstract art is sometimes represented to be. I am not trying to say that Ben Nicholson's paintings and reliefs *are* architecture. They are not. They have grown, steadily and naturally, out of the painting tradition. But they represent, in a sense, architectural form detached from its functional moorings and raised to a poetic plane.

Look at it in this way: The front of a house, with a door and a window, signifies two things. It signifies an *ensemble* of 'house', 'door' and' window'. But it has another significance which can only be expressed in terms of related rectangles. If you had never seen a house in your life, it is this latter significance which would strike you first and most forcibly. In architecture, these relationships are mostly very simple: window comes over window, window over door; horizontally, everything is lined up to agree with the floor levels. But suppose you design a house which is no house but just a constructed shape? You are free then to arrange your rectangles how you like; you are at large in a world where your liberty of choice is positively embarrassing. Embarrassing, that is, when considered as foot-loose

architecture. But what happens when not an architect but a painter breaks into this world – a painter whose whole life is directed to the cultivation of that mysterious language of form which lies beneath the currency of name and appearance? The answer – one answer – is the work of Ben Nicholson.

A common objection is that this sort of thing is a meaningless simplification of the artist's business. Cut adrift from architectural purpose on the one hand and representation on the other, he is rudderless, a sterile grammarian, an essayist in diagrammatic spacing. Nicholson's development during the past ten years disproves this. Study his achievement as a whole and you will find, first, that he is one of the very few contemporary artists properly equipped for a voyage of discovery, and second, that he *really is discovering*. For such discoveries there is no intellectual test. The only test is intuitive; the only palpable demonstration of their validity is their recognition by other artists and designers. This is apparent in many directions, not least in the work of those who 'do not believe' in abstract art.

The limitations of this sort of exploration are obvious. Nicholson's art is not exactly a popular art. It has no social importance in the obvious sense of wide appreciation, though I think that may come in time; and in any case, the social importance of painting can hardly be assessed in terms of gallery attendance. At the present time the work of an authentic abstract painter might be compared to advanced research in scientific thought, in so far as its results reach out a very long way from the common world of everyday affairs and everyday visual experience. Their importance is not less for that and their ultimate effect is likely to be considerably more. Those who must have a 'social sanction' for any work of art to which they extend their admiration, should remind themselves that it is to the work of artists in the abstract tradition that the whole of the modern vernacular in architecture, in industrial design, in printing, in publicity art, owes its origin.

I have left myself little room to talk about the exhibition of the Reid and Lefevre Gallery which is the real subject of this article. Some of Nicholson's new paintings seem to me irresistible; their apparent simplicity lays bare the complexity which results from the placing together of areas of different proportion, different texture, different colour – a complexity which the painter controls and makes eloquent in an extraordinary way. The all-white reliefs are less easy on the eye; the same complexity is there, but the emotional assault of colour is not, and this produces a remoteness approaching inaccessibility for the ordinary observer.

In the same gallery, nine other abstract painters are

exhibiting. None of them are 'discoverers' to the extent that Nicholson is. One recognises allegiances to the past: here to Wyndham Lewis, here to Kandinsky, here to Léger, here to Ben Nicholson of 1930. Ashley's hard, clear, immaculate studies suggest a half-way house between creative and decorative design. Tunnard's essays in texture are rich and charming; Morton, Stevenson and Jackson are moving in a direction parallel to Nicholson; while Johnstone, Glass, Wright and Evans are the authors of synthetic statements more or less easily placed in relation to the general trend of contemporary European art.
['Abstract painters', *The Listener* Vol XXI no 531, 16 March 1939, p 574]

J M Richards

. . . For both of these sculptors [Gaudier-Brzeska and Henry Moore] their technique is not so much the means to an independent end as an integral part of it; but the carver finds in his material natural forms characteristic of its kind, while the modeller's material is amenable to almost any invention; so that in Henry Moore's work particularly, as a logical consequence of his philosophy, the ultimate expression not only has the material as its vehicle, but has its form always conditioned by it. The work of the artist becomes a kind of idealisation of matter in which the sculptural qualities are already inherent — an enunciation of what is relevant and elemental. Henry Moore's works, the satisfying shapes that he produces, seem consequently to have been made by a process of denunciation or detrition, the selective process bearing a close relationship, improved by a more exact elimination of accidental influences, to the physical processes to which the same material is, under natural conditions, habitually subject.
. . . Other remarks of his [Herbert Read's] notably those on the present position of sculpture in general — or rather on its lack of position in active (as opposed to dilettante) society — are well worth repeating:

'A communal art can only thrive if there is a communal consciousness of it, and a communal demand for it: and actually there has been no communal demand for sculpture in this country for many centuries. There has, it is true, been a trade in tombstones and sepulchres, and these have sometimes, notably in the seventeenth and eighteenth centuries, been given monumental proportions. But although in rare cases such monuments have architectural dignity, they rarely possess any sculptural significance. The practice and appreciation of sculpture in England has been virtually dormant, if not dead, since the Middle Ages.
Two assumptions underline such a statement: the first is,

that the dilettante craze for antique sculpture, which flourished from the Renaissance until modern times, had rarely, if ever, any aesthetic basis. It was partly a cultural snobbism, partly a genuine historical or archaeological interest, the by-product of the classical bias in education . . .

The second assumption is more fundamental: it is the distinction between carving and modelling. First let me say that it is not a distinction between a good technique and a bad one. I am inclined to think that carving has produced greater works of art in the past than has modelling, but that may be a prejudice of my particular kind of sensibility. The distinction, that is to say, is not one of aesthetic values, but of aesthetic categories — a distinction of kind, not of degree.

Further, I do not think it is a distinction between two methods of arriving at the same result — in that case it would be merely a difference of methods, not of kinds. But the distinction is often explained as one between adding and subtracting, between 'putting on' and 'taking off'. Actually, carving *can* be as plastic as modelling if the carver is actuated by a modelling conception; and clay could conceivably be carved by some sculptor with a low blood-pressure. The real distinction is one of conception, of psychological attitude . . .

The parting of ways would seem to come when the conception impinges on the material. Then a different degree of resistance is encountered, and the result, when the material is stone, is a tension altogether greater than meets the artist in clay. Every work of art is a coalition of idea and material; success depends on finding a perfect balance. If the idea demands compactness, the greatest possible degree of centripetal coherence, then stone will be the appropriate material, and carving the appropriate technique; if, on the other hand, the idea demands the greatest degree of centrifugal expansion, an open form, then the appropriate material will be clay, and modelling the appropriate technique. Bernini is the exception that proves the rule; only the colossal insolence of his baroque genius could achieve the paradox of adopting marble to the plastic formulas, not merely of clay, but even of paint.

In the end, therefore, this distinction between carving and modelling is seen to depend on an almost ethical injunction, which might be expressed in three words: truth to material.'
['Henry Moore, sculptor', *Architectural Review*, Vol LXXVI, September 1934, pp 90 – 91]

S John Woods

'It is the natural beauty of proportion of the phallic consciousness, contrasted with the more studied or ecstatic proportion of the mental or spiritual consciousness we are accustomed to.'

D H Lawrence meant the Cerveteri tombs but the passage applies with equal relevance to sculpture. Sculpture to-day has been forced into the place of a rather younger and less important sister of painting — a place which has caused its individuality to suffer and its specific qualities to dwindle from sight.

Sculpture is more primitive, in the purest sense, than painting; it is more solidly bound to earth and less capable of becoming sophisticated. Its materials, stone and wood, existed before man and existed *as sculpture*; its formal basis, the pebble fashioned by the sea, or the tree-trunk, are phallic and, subsequently, tactile. This phallic-tactile quality both marks the main difference between sculpture and painting and serves to show that sculpturally the advanced abstract position, where space values have superseded mass values (excellently analysed by Moholy-Nagy in *New Vision*) is a masquerade: a masquerade, that is to say, in so far as it claims the name of sculpture when it has, in fact, become something basically different. It is not the analysis of the progress which errs but the reference of that progress to one entity when in fact it is the transmutation of one entity into another, of sculpture, with all its natural, primitive, phallic-tactile attributes into space-construction which is unnatural, sophisticated and scientific.

But alongside the space-constructions of Moholy-Nagy, Gabo and others, sculpture continues; the animal has produced a mind but its body remains intact. We find it in Brancusi, Arp, Giacometti and Moore. The sculpture of all these is phallic-tactile, solidly based on nature and, in varying degrees, primitive. With an austere selection of means Brancusi has reached an awe-inspiring end. Taking a head, a bird, a fish he has made concrete the ideal, a personal ideal but perfect within chosen limits. Arp has made a similar but more complex selection and, playing on the motive of woman, has produced less tensions, less *perfection*, but more variety. Giacometti reaches out from his corner and pokes his thumb in the surrealist pie — but the plum is all his own.

And Moore? Moore is the primitive in the purest sense. But his primitiveness is neither the primitiveness of the savage nor of the *noble savage*; there is no museum dust or cobwebs nor is there false romanticising. His primitiveness is of the twentieth century but has no counterpart in contemporary art. Perhaps he is nearest to D H Lawrence. Neither of them bears the streamlined, chromium insignia of our age, neither of them bows to the intellect or to the machine, while both are essentially primitive. Lawrence's concern is with man and woman. Moore with woman but differently; for there is no man.

As, too, with Lawrence there is no violent change of direction in Moore's work over a period of years; there is little to be said about the 1936 carvings, now on exhibition at the Leicester Galleries, that would not apply to the 'Mountains' of 1930; only the degree of abstraction has altered — but is that so important?

Soon the relative unimportance of the word abstract will become clear. With the exception of constructivism no art is abstract in the pure meaning of the word. All so-called abstract pictures are based in some degree on nature or, more exactly, on the artist's selection of certain phenomena of nature. And the three most common selections — the still-life, the figure composition and the landscape — are still valid for abstract pictures.

The cubist movement was a still-life movement and, as abstract art was born from cubism, that too is mostly but by no means completely dominated by the still-life. Picasso painted guitars, fruit dishes, wine-bottles, and in his few abstract paintings these are still implicit; Ben Nicholson painted cups and saucers and in his white reliefs the mug without a handle, the circular top of a saucer, the white edge of a tablecloth are there, disintegrated and perhaps invisible; in Miró the derivation is direct and organic; in Hélion bodies are suspended in space almost as a memorial to Poussin; in Piper the sea beats on rugged cliffs and surges round the smoothworn lighthouse walls. This century has not destroyed the still-life, the figure composition, the landscape, but freed them; the actual sphere of art has been very little altered, only the treatment has been widened and liberated.

And Moore is never far from woman. A breast or an eye focalises the mass of stone, gives it a superaesthetic value, stabs with surprise on its realisation and creates the perfect balance between truism and falsehood, fact and impossibility, which is art. Art never really alters; its materials alter, its purposes — the inessentials — but the stuff of which its value is made remains the same for Egypt, Mexico, mediaeval England, Benin or Henry Moore, for 4,000 BC or for 1936. Basically there is only good art and bad art and the standards inevitably depend on the present; the past and the future are only important, in fact only exist in the present. New artists arise and new forms of art arise with each generation. And occasionally there is an artist like Henry Moore to show the essential constancy of art.

['Henry Moore', review in *Axis 7*, Autumn 1936, pp 28–30]

Henry Moore

. . . This is what the sculptor must do. He must strive continually to think of, and use, form in its full spatial completeness. He gets the solid shape, as it were, inside his

head — he thinks of it, whatever its size, as if he were holding it completely enclosed in the hollow of his hand. He mentally visualises a complex form from all round itself; he knows while he looks at one side what the other side is like; he identifies himself with its centre of gravity, its mass, its weight; he realises its volume, as the space that the shape displaces in the air.

. . . Since the Gothic, European sculpture had become overgrown with moss, weeds — all sorts of surface excrescences which completely concealed shape. It has been Brancusi's special mission to get rid of this overgrowth, and to make us once more shape-conscious. To do this he has had to concentrate on very simple direct shapes, to keep his sculpture, as it were, one-cylindered, to refine and polish a single shape to a degree almost too precious. Brancusi's work, apart from its individual value, has been of historical importance in the development of contemporary sculpture. But it may now be no longer necessary to close down and restrict sculpture to the single (static) form unit. We can now begin to open out. To relate and combine together several forms of varied sizes, sections and directions into one organic whole.

Although it is the human figure which interests me most deeply, I have always paid great attention to natural forms, such as bones, shells, and pebbles, etc. Sometimes for several years running I have been to the same part of the sea-shore — but each year a new shape of pebble has caught my eye, which the year before, though it was there in hundreds, I never saw. Out of the millions of pebbles passed in walking along the shore, I choose out to see with excitement only those which fit in with my existing form-interest at the time. A different thing happens if I sit down and examine a handful one by one. I may then extend my form-experience more, by giving my mind time to become conditioned to a new shape.

There are universal shapes to which everybody is sub-consciously conditioned and to which they can respond if their conscious control does not shut them off.

Pebbles show nature's way of working stone. Some of the pebbles I pick up have holes right through them.

. . . Sculpture is more affected by actual size considerations than painting. A painting is isolated by a frame from its surroundings (unless it serves just a decorative purpose) and so retains more easily its own imaginary scale.

. . . The violent quarrel between the abstractionists and the surrealists seems to me quite unnecessary. All good art has contained both abstract and surrealist elements, just as it has contained both classical and romantic elements — order and surprise, intellect and imagination, conscious and unconscious. Both sides of the artist's personality must play

their part. And I think the first inception of a painting or a sculpture may begin from either end. As far as my own experience is concerned, I sometimes begin a drawing with no preconceived problem to solve, with only the desire to use pencil on paper, and make lines, tones and shapes with no conscious aim; but as my mind takes in what is so produced, a point arrives where some idea becomes conscious and crystallises, and then a control and ordering begin to take place.

Or sometimes I start with a set subject; or to solve, in a block of stone of known dimensions, a sculptural problem I've given myself, and then consciously attempt to build an ordered relationship of forms, which shall express my idea. But if the work is to be more than just a sculptural exercise, unexplainable jumps in the process of thought occur; and the imagination plays its part.

It might seem from what I have said of shape and form that I regard them as ends in themselves. Far from it. I am very much aware that associational, psychological factors play a large part in sculpture. The meaning and significance of form itself probably depends on the countless associations of man's history. For example, rounded forms convey an idea of fruitfulness, maturity, probably because the earth, women's breasts, and most fruits are rounded, and these shapes are important because they have this background in our habits of perception. I think the humanist organic element will always be for me of fundamental importance in sculpture, giving sculpture its vitality. Each particular carving I make takes on in my mind a human or occasional animal, character and personality, and this personality controls its design and formal qualities, and makes me satisfied or dissatisfied with the works as it develops.

My own aim and direction seems to be consistent with these beliefs, though it does not depend upon them. My sculpture is becoming less representational, less an outward visual copy, and so what some people would call more abstract; but only because I believe that in this way I can present the human psychological content of my work with the greatest directness and intensity.

['The Sculptor speaks', *The Listener* Vol XVIII no 449, 18 August 1937, pp 338 – 40]

William Gibson

. . . In her work, as in most abstract art, one can often trace the probable starting-point in nature, in shapes suggestive, for instance, of the human form or of ships lying on the beach. Miss Hepworth has not obscured the issue by naming her sculpture after the original starting-point. Her interest is in certain qualities only in the natural object and

she makes her adjustments logically in accordance with it. She shows an interest in a number of formal qualities, in the rhythmical variations, for example, afforded by spheres and spherical hollows, or in the relationships of other somewhat similar forms, but before anything else her work succeeds or fails in accordance with its power to work the stimulating sense.

. . . In an essay in *Circle*, as cryptic as most modern essays on aesthetics, Miss Hepworth states: 'Contemporary constructive work does not lose by not having particular human interest, drama, fear, religious emotion. It moves us profoundly because it represents the whole of the artist's expression and vision, his whole sensibility to enduring ideas, his whole desire for a realization of these ideas in life and a complete rejection of the transitory and local forces of destruction.' This may or may not mean that Miss Hepworth's interests are consciously solely in the qualities which I have suggested. But one may legitimately object to her classifying the other interests as non-enduring. Furthermore, while agreeing that the two kinds of interest cannot be compared and that one cannot speak of loss or gain – one must accept from the artist what he has to give, and Miss Hepworth has a lot to give – yet, thinking again of the cowherd of the Acropolis Museum, one may state that there are subjects of which the greatest art may be made, which Miss Hepworth's modern artist ignores.

This is intended in no way as blame. Indeed, the October exhibitions as a whole show how a stubborn clinging to impressionism may lead even gifted artists to a vulgarity bordering on that of the Royal Academy. The oasis in this desert of commonplace vision are Miss Hepworth's exhibition and that of M Léger at the London Gallery, in which he combines his usual sense of formal design with, particularly in his *Gouaches*, a new feeling for his material. The moral seems to be that to-day the qualities to which Miss Hepworth refers in the passage quoted, are those of which creative sculpture and paintings are made.
['Barbara Hepworth', *London Mercury* Vol XXXVII no 217, November 1937, pp 57 – 58]

Anthony Blunt

. . . At the Lefevre Galleries is the greatest specialist of all, Barbara Hepworth. She is exhibiting sculptures of which the essence is, according to Dr Bernal who writes a learned foreword to the catalogue, the subtle interplay of one curved surface with another. The sculptures have, as Dr Bernal observes, great likeness to certain Neolithic Menhirs; but it is hard to see what relevance the refined aesthetic treatment of problems, which seem to have been a matter of religious convenience to Neolithic man, can have at the present time. The study of primitive arts has supplied new aesthetic blood to sculpture during this century, but at the moment it is not new aesthetic blood that is wanted, but a revitalisation of art by contact with life. To praise Miss Hepworth's sculptures seem to me like saying that a man is a good orator because the shapes which his mouth makes when he speaks are aesthetically satisfying.
['Specialists', *The Spectator* no 5704, October 22 1937, p 683]

Herbert Read

The problem re-stated
The problem, it will now be clear, is not the simple one: can the machine produce satisfactory works of art; that is to say, in the sense of Ruskin and Morris, can the machine continue the tradition of ornament characteristic of European art since the Renaissance? If that were the only problem, it has long since been answered by practical demonstration. The machine product has no need of such ornament, and even if it had any need of it, could not produce it.

The machine has rejected ornament; and the machine has everywhere established itself. We are irrevocably committed to a machine age – that surely is clear enough now, eighty years since the publication of *The Stones of Venice*. The cause of Ruskin and Morris may have been a good cause, but it is now a lost cause.

Leaving on one side the economic and ethical problems involved (such problems as the displacement of human labour and the use of enforced leisure), we are left with the only problem for present discussion: CAN THE MACHINE PRODUCE A WORK OF ART? One might put the question less crudely; one might ask, for example, whether the machine can satisfy the aesthetic impulses the satisfaction of which we believe to be a biological necessity. Or one might ask whether man can find in machine production sufficient exercise for his constructive faculties, for that structural science which is one element in all art. Or from still another angle, one might ask what is the function of the artist in the machine age? But the simple question: *Can the machine produce a work of art?* includes all these subsidiary and related questions.

Our discussion of the general nature of art has left us with two distinct types:
humanistic art, which is concerned with the expression in plastic form of human ideals or emotions; and
abstract art, or non-figurative art, which has no concern beyond making objects whose plastic form appeals to the aesthetic sensibility.

We found further that objects of abstract art might appeal 69

to our sensibility either for physical or rational reasons, because they obeyed certain rules of symmetry or proportion; or that they might appeal – perhaps not to our sensibility in the accepted sense of the word, but to some obscurer unconscious faculty, because of a formal quality which is beyond analysis.

These distinctions being made, my contention is then that the utilitarian arts – that is to say, objects designed primarily for use – appeal to the aesthetic sensibility *as abstract art*; and we concluded that this appeal might be irrational; that the form of objects in use is not simply a question of harmony and proportion in the geometric sense, but may be created and appreciated by intuitional modes of apprehension.

Since what I have called rational abstraction in art is measurable, and resolves into numerical laws, it is obvious that the machine, which works to adjustment and measure, can produce such works with unfailing and unrivalled precision. Such beauty as we admire in Greek vases, and in the undecorated forms of Mediterranean art generally, can undoubtedly be produced by machinery, and in materials more suitable than any available to Classical or Renaissance artists. All the objects of machine manufacture illustrated in this book demonstrate the fact. Such objects can satisfy all the canons of beauty which have a basis in numerical proportion. The artist is the individual (generally called the *designer*) who decides the proportions to which the machine works. His problem is to adapt the laws of symmetry and proportion to the functional form of the object that is being made.

Such a designer only differs in degree (in the nature of his materials and the simplicity of his object) from the designer of a motor-car, a building or a bridge. The most typical designer of the machine age is the constructive engineer. In so far as he reconciles his functional aims with ideals of symmetry and proportion, he is an abstract artist.

But we have concluded that the highest kinds of abstract art are not rational. The highest kinds of abstract art cannot be worked out by rule and measure. They depend on an intuitional apprehension of form. We are therefore finally reduced to asking ourselves whether machine methods are capable of producing these subtler forms.

Standardisation
Naturally such forms will be standardised and uniform. That does not seem to me to be an objection, if they conform to all other aesthetic requirements. The quality of *uniqueness* must obviously be sacrificed in the machine age. But what is the worth of such a quality? It is certainly not an aesthetic value. The sense of uniqueness – is it not rather a reflection of the possessive impulse, an ethically unworthy impulse typical of a bygone individualistic phase of civilisation?

If there were any danger of a shortage of machines, so that all diversity disappeared from daily life, there would be some cause for alarm. But actually machines multiply and change rapidly, and their products are of far greater diversity than those produced by handicraft.

Let us dismiss, then, any fears we may have of standardisation.
[*Art and Industry*, Faber and Faber, London 1934, pp 33–37]

S John Woods

'Typographische Gestaltung,' by Jan Tschichold.
Exhibition of Typography by Jan Tschichold *at Lund Humphries.*
If you go to an English printer and ask for Welt Antiqua you will be offered Memphis: 'Just as good.' If you ask for Cable you'll be told Gill Sans is 'just the same.' Complain because Rockwell is used instead of Beton and you'll be regarded as a pedantic idiot. English printers are type-blind; they work on a set of a priori principles and assumptions – completely non-creative. With the possible exception of Lund Humphries, who occasionally do more than import a fashion.

Look at English art books and periodicals: 'Unit One' was a farcical piece of pseudo-Teutonism; 'Art Now' was better, but the body-matter in Gill was difficult to read; Gascoyne's *A short survey of Surrealism* was several years out of date; *Five on Revolutionary Art* was probably the best job of typographical layout Kauffer has done, but between the covers it was ordinary; *Axis* is, to my mind, too conventional in form for its contents.

In the last twenty years progress in typography has chiefly come from Germany. Last year's exhibition of work by Koch's Klingspor Press at Lund Humphries, that of Jan Tschichold at the same gallery, and Tschichold's book *Typographische Gestaltung*, make English typography look silly.

In the past, display typography was based on the Italian hour-glass title-page; wide measure top and bottom, narrowing in the centre. Through the work of such men as Tschichold this tradition has been shaken off, asymmetrical layouts have resulted and, most important of all, the white space of the page has been realised in its true importance as a part of layout and not as emptiness to be filled. In his book Tschichold illustrates abstract-works by Tauber-Arp, Ben Nicholson, Moholy-Nagy and others alongside pretty black and white diagrams of the elements of typography and their use in relation to the printed page.

Typography is an art of great flexibility. Because it reaches limitless eyes it ranks as one of the most influential fields of design. In which case the sooner Tschichold's theory and practice penetrate to England the better.
[A review in *Axis* 5, spring 1936, p 28]

Herbert Read

. . . More interesting are the figures which show the positive results on sales following the introduction of particular designs. The most striking of these relate to the Swedish glass industry, but almost equally striking are those relating to wireless cabinets. In 1931 the firm of E K Cole, Ltd., realised the great possibilities which might lie in the use of synthetic materials, such as bakelite, in which the whole of a cabinet might be moulded in one piece. They acquired the necessary plant, at considerable expense and risk, and approached Serge Chermayeff and Raymond McGrath, two of the most enterprising architects in the country, to design new models, regardless of any of the conventional forms already on the market. To begin with, one of Chermayeff's models was chosen. 'The shape of it was something completely new, nothing comparable existed, either in England or abroad. It was the result of a careful study of function and a genuinely artistic imagination . . . If the sales did not exceed 10,000 sets in the first year it would be a serious failure. What happened remains as an immense credit to the English public. The new cabinet . . . became exceedingly popular almost from the first month. About 100 per cent. more sets were sold in the 1933–4 season than in the previous season'. The next year the firm called for fresh designs and selected a circular model by Wells Coates, even more startling and unprecedented in appearance. The result was equally successful. The turnover of this firm is now £1,250,000 as against £200,000 in 1930.

The significance of experiments like this is that they go far to disprove the usual contention of manufacturers that the public is either indifferent to good design, or actually prefers a bad design. By such arguments they excuse their own indifference, complacency and laziness. The fact, which Dr Pevsner also brings out [in his book *An enquiry into industrial art in England*, Cambridge 1936], that good new designs tend to be introduced in slump periods rather than in prosperous periods, points in the same direction. Nobody can deny that the public is ignorant and insensitive, but the taste they have formed has been formed in the shops and markets, and the shops and markets have been stocked by exploiters without any public conscience, men who have ignored Ruskin's command to them 'to form the market as much as to supply it'.

Dr Pevsner's general conclusion is a formidable indictment of modern industry. He reckons that not more than 5 or 10 per cent. of products are well designed, and that on the whole the condition is worse in this country than on the Continent. If it were a question of an innate lack of taste in the public, we should expect that condition to be spread equally over the whole of our industrial production, but that is by no means the case. In certain trades, notably sports articles, travelling goods, motor-cars, sanitary appliances, watches and metal windows, design is on the whole excellent. Lettering, on metal as well as on paper, is hardly inferior, whilst in furnishing fabrics, above all tweeds, linens, crashes and printed materials, some English goods are almost the best produced anywhere. If we can discover the reason for this variable standard of design in different trades, we might be near solving the general problem and suggesting a remedy.

Dr Pevsner examines the various possibilities. Is it a question of the size of the manufacturing unit? Or of the organisation of the manufacturing unit? Is it a difference between old and new industries, between objects for use and objects for adornment, between hand-made and machine-made articles? Is it merely a question of cost – of not being able to afford a good designer? None of these explanations will suffice, though they will account for occasional anomalies. That in a general sense our bad taste is a by-product of our social and economic system is a truth which Dr Pevsner does not attempt to hide. But that it is not a simple consequence of the capitalist system is shown by the significant case of the Co-operative Movement in this country. Here is a vast manufacturing and distributive agency responsible for something like 20 per cent. of the total consumption of goods in this country. It is exempt from the usual profit motive and is controlled for the mutual benefit of its eight million members. Here, surely, is an opportunity to establish a high standard of design. But what, in effect, do we find? I think most disinterested critics of design would agree that the artistic standard of the Co-operative Movement is one of the lowest in the industrial world. Its shops may be efficiently run, but they are architecturally commonplace, if not vulgar; whilst the goods inside the shops – from carpets, linoleum and furniture down to packages and wrappers – if not positively hideous, are drab and uninspired. It would be interesting to know what apology the directors of the Co-operative Movement can make for this state of affairs. The success of such well-designed products as the Ekco and Murphy wireless cabinets, the Finnish bent plywood furniture, Ferranti electric fires and Wedgwood pottery, proves that good design is not in itself a detriment to sales; and if these

examples are not convincing enough, we need only turn to an inescapable parallel in Sweden. There the Co-operative Society is actually the leader of fashion and quality. The designing of its factories and shops, its window-dressing and all its goods and packages, is under the direction of the best contemporary architects and artists.

The conclusion of the whole matter is that whilst much can be done to improve public taste by education in schools and exhibitions, and by the propaganda of such bodies as the Design and Industries Association, the essential factor is the goodwill of the manufacturer. To promote that goodwill we need the kind of leadership which in an isolated area like London has already been given by the London Passenger Transport Board. It is within the province and power of the Co-operative Movement to give that lead on a nation-wide basis, and unless it does so it must inevitably forfeit the support of all who regard design as of fundamental importance in the work of social reconstruction.
['An enquiry into public taste', *The Listener* Vol XVIII no 443, 7 July 1937]

Reginald Blomfield

. . . In an international exhibition of modern architecture held at Milan (1933) there was shown 'a rest-room in a steel tenement house' in the Modernist manner. This 'rest-room' was a long, very narrow room with the whole of one side filled in with glass. The designer seems to have thought that he must be all right if the whole of one side of his room was glazed, but a well-lit room is neither all light nor all shade, but the result of the balanced adjustment of both. Any place more utterly unsuitable for rest and quiet than this room I cannot imagine. These apostles of efficiency are so amazingly inefficient. The result of a continuous line of windows (a favourite trick of the new manner much affected by Herr Mendelssohn) must be that the partition walls of the rooms run out into the windows, without any returns, with no place where you can keep out of the draught, or if necessary out of the light. What happens when summer heat is at 80°F and in winter when it is 20°F below freezing-point? If 'modern people think and do and want these things' they must be a strange race, resembling those famous spinsters of whom it was said:

Miss Buss and Miss Beale
Cupid's darts do not feel:
How different from us;
Miss Beale and Miss Buss.

Moreover, to borrow a useful phrase of Mr Trystan Edwards — there is such a thing as good manners in architecture — and what might be endurable in a suburb of Paris or Berlin is

quite intolerable on the Chilterns and the English countryside . . .

By the 'New Architecture' I do not mean contemporary architecture that moves freely and boldly on more or less traditional lines; such, for example, as the work of Westmann, Tengbom, and Ostberg in Sweden, and several very able colleagues of my own in England, young as well as old. The New Architecture that I refer to is that movement now widely recognised on the Continent as such, and widely prevalent in Europe and America, a conscious and deliberate change in the whole orientation of architecture. It has entirely superseded the 'Pompier manner' of the Opera House at Paris, with its unconvincing parade of magnificence, and a very good thing too. But it has dashed off into the opposite extreme of crude and unabashed brutality, and total disregard of the amenities of town and country . . .

I must confess that in these extravagant forms it makes little appeal to me; yet one must admit that in its effort at simplification, its dismissal of meaningless ornament and contempt for prettiness, its anxiety to do everything with a purpose, however wrongly that purpose may be conceived, the New Architecture is right in principle as far as it goes, and in its origin it had a real justification in the misconception of architecture that made the nineteenth century so futile.
[*Modernismus*, MacMillan 1934, pp 51 – 52]

Marcel Breuer

. . . I should like to consider traditionalism for a moment. And by tradition I do not mean the unconscious continuance and growth of a nation's culture generation by generation, but a conscious dependence on the immediate past. That the type of men who are described as modern architects have the sincerest admiration and love for genuine national art, for old peasant houses as for the masterpieces of the great epochs in art, is a point which needs to be stressed.

. . . It may, perhaps, seem paradoxical to establish a parallel between certain aspects of vernacular architecture, or national art, and the Modern Movement. All the same, it is interesting to see that these two diametrically opposed tendencies have two characteristics in common: the impersonal character of their forms; and a tendency to develop along typical, rational lines that are unaffected by passing fashions.

. . . In one direction at least our modern efforts offer a parallel — we seek what is typical, the norm; not the accidental but the definite *ad hoc* form. These norms are designed to meet the needs, not of a former age, but of our

own age; therefore we naturally realize them, not with craftsmen's tools, but with modern industrial machinery.

If one examines a *bona fide* example of industrial standardization, one cannot fail to perceive that it is representative of an 'art', and that that art has only reached this point of perfection by a sort of traditional development which is the result of exploring the same problem over and over again. What has changed is our method: instead of family traditions and force of habit we employ scientific principles and logical analysis.

. . . The second dominant impulse of the Modern Movement is a striving after clarity, or, if you prefer it, sincerity. No romantic tendencies are implied in either of these terms. They do not mean that we wear our hearts on our sleeves, or invite all and sundry to pry into our homes and private lives through our long horizontal windows.

. . . The principle of clarity, as we understand it, expresses itself in the technical and economic fields of architecture, through emphasis on structural laws and practical functions; and in the aesthetic field by simplicity and a renunciation of all irrational forms. The New Architecture might be compared to a crystalline structure in process of formation. Its forms correspond to human laws and functions, which are other than those of nature or organic bodies. In its more immediate conception this New Architecture of ours is the 'container' of men's domiciles, the orbit of their lives.

Are our buildings identifiable with descriptions such as 'cold', 'hard', 'empty-looking', 'ultra-logical', 'unimaginative and mechanistic in every detail'?

. . . The origin of the Modern Movement was not technological, for technology had been developed long before it was thought of. What the New Architecture did was to civilize technology. Its real genesis was a growing consciousness of the spirit of our age.

. . . Perhaps the slogan: 'Art and technique as a new unity', which Gropius coined some years ago, most nearly expresses the idea that in the New Architecture these concepts are no longer separable.

I now come to the third dominant impulse of the Modern Movement: the relation of unbroken elements to one another — contrast. What is aimed at is *unschematic design*.

. . . We strive to achieve a definite design for all different elements, and we arrange them side by side without dressing them artificially for the purpose. These elements receive different forms as a natural consequence of their different structure. Their complete individuality is intended to establish a kind of balance which seems to me a far more vital one than the purely superficial 'harmony' which can be realized by adopting either a formal or a structural common denominator.

. . . Contrasts like house and garden, a man's working and home life, voids and solids, shining metal and soft materials — or even living organisms like animals and plants — can all be realized against the stark plain surface of a wall; also in the opposition of the discipline of standardization to the freedom of experiment that leads to its development. Such contrasts have become a necessity of life. They are guarantees of the reality of the basis we have chosen to adopt. The power to preserve these extremes without modification (that is to say, the extent of their contrast) is the real gauge of our strength . . .

['Where do we stand?', *Architectural Review* Vol LXXVII, April 1935, pp 133–136]

J M Richards

Towards a Rational Aesthetic: An Examination of the Characteristics of Modern Design with Particular Reference to the Influence of the Machine

. . . Modern Characteristics
Conformity with a new set of conditions — with a new world of experience — means the adoption of a new aesthetic. The nature of this machine aesthetic is perhaps best defined by examining the typical qualities of such objects and designs as have already been produced to conform with it; the common characteristics, in fact, of modern design, particularly in the way they differ from those of handicraft design; the new vocabulary of the Modern Movement.

First of all, by a machine aesthetic is not intended, of course, an aesthetic admiration for machines as substitute works of art. It implies appreciation of those qualities that have been introduced into art by the machine. It means perception of the machine art-forms and acceptance of the modification of the handicraft art-forms brought about by the machine. It means a changed vocabulary in conformity with the new unity of values.

What are the characteristic terms of this new vocabulary? The first is simplicity. Simplicity is almost a prerequisite in modern design for several reasons. One, the least important, that we are undergoing a reaction against the elaborate ornamentation of the nineteenth century — a subjective and ephemeral reason for simplicity which would only have importance if the Modern Movement were being interpreted as a new style, similar in kind to the many conflicting styles of the nineteenth century, instead of as the natural outcome of a new scale of organization. Secondly comes the growing complication of modern existence, resulting in our being subjected to a perpetual succession of stimuli, to counteract which a negative rather than a

73

competitive environment is essential. The products of handicraft were designed to hold interest; those of machines to distribute it. Thirdly, the effect of our greater knowledge of materials. Knowledge of materials means interest in materials for their own sake, and greater respect for them. Simple surfaces, of a nature appropriate to mechancial processes, take the place of applied ornament, which destroys the integrity of the material. Finally, probably the most important cause of simplicity in modern design is an even more immediate result of the application of power to industry — of the source of energy being divorced from the control of it: the loss of the virtue that attaches to complication in execution. In the handicraft period technical virtuosity, resulting in elaboration of forms and detail, was an expression of the personal skill of the worker. With emphasis transferred from the worker to the work done the urge to virtuosity disappears. The machine has destroyed the belief that a thing is more beautiful because more expertly made or because more difficult to make. It has not destroyed the virtue of craftsmanship. It has liberated the craftsman from the routine of production, and transferred his special qualities from the process to the object.

. . . The Machine as Precedent

The abandonment of the craftsman's own personal part in execution, as distinct from his influence on design, leads us to the second modern characteristic: emphasis on the impersonal. Modern design concerns itself with generic types rather than with *ad hoc* products. The search for the standard or type form is the paramount task of the modern designer. This characteristic is, of course, closely bound up with the question of standardization — the factual corollary of mass production — the most typical contribution of the industrial revolution to everyday life. The impersonal nature of modern design has, however, other causes than the impersonal nature of the machine process. The chief of these is the example, as a design precedent, of the machine itself. That an efficient machine is *ipso facto* a work of art is a belief, that of pure functionalism, that cannot be seriously sustained. Many machines (including in that category works of engineering) are also works of art, owing probably to unconscious selection of alternative solutions for aesthetic reasons on the part of the designers; but if machines generally are not works of art their nature underlies modern works of art. Study of machines as objects and analysis of their several beauties have added many qualities to the designer's vocabulary: among these is an appreciation of the formal, abstract relationships of machine forms. There is no need to point out the debt to the machine owed by certain schools in the so-called 'fine' arts, notably the cubists and the constructivists. Both the machine and the artist have been engaged in resolving the organic world into its essential geometrical elements. The constructions of such artists as Pevsner, Gabo and Moholy-Nagy are in fact machines that happen to be non-utilitarian in the purely productive sense. The possibility of their existence, incidentally, points *per contra* to the weakness of the 'beauty out of pure function' theory. So many of the formal values of the machine have little connection with the machine in operation.

. . . In rejecting the simple philosophy of pure functionalism, modern design also avoids the functional exhibitionism that is its aggravated form: the conscientious display of the means, and the unnatural emphasis on characteristic forms. The misleading phrase, 'to express its purpose', is made the excuse for a new, a historical brand of stylization.

A sharpening of our perception of abstract formal relationships, through the observation of machines and machine-made things, is accompanying the disappearance of the handicraft quality — the personal contribution of the skilled workman. Design, as with culture, is becoming abstract rather than humanistic.

. . . Standardization

Power production and its equivalent in terms of work, mass production, have made standardization applicable to almost every sphere of design.

It cannot be too often repeated that standardization, a word that is often misapprehended, does not mean monotony or sameness. It means, rather, a liberation of objects with certain intrinsic formal characteristics from accumulations of the ephemeral and the inessential. Standardization is a pre-requisite of mass production and mass production is typical of power technique, but examples of standardization — even of mass production — are by no means unknown in the handicraft era — quite apart from the fundamental standardization of goods in the form of money. The commonest example is, of course, in printing, the printed page being a perfect mass product. The military arts produced the earliest examples of mass production in industry in the same way that they were the birth centre of much technical invention.

. . . Indeed, many characteristics of the modern aesthetic existed separately in various phases of the historical periods; for example, the tendency towards dehumanization and mechanization of labour in Egypt, and the Hellenic impulse towards clarity coupled with a progressive geometrical refinement.

Allied with the implications of standardization is what

might be termed the aesthetic virtue of regimentation: the appreciation, typical of the machine age and deriving from machine forms, of the series or the group of identical units. The search for order already referred to is reflected in the delight taken in the regularity of sheer repetition. This addition to the aesthetic vocabulary has probably been increased by air travel and high building – by the bird's eye view, in which such repetition of identical forms commonly occurs, and which gives a toy-like quality to organised objects repeated to a minute scale that conduces again to the typical objective vision.

New Appreciations
The quality of exactness demanded of modern design has already been referred to as a further reflection of the new order which is based on system, the search for knowledge and order having resulted in dissatisfaction with what is approximate and indefinite. The appeal of vagueness and of the picturesque gives place to the aesthetic satisfaction of the mathematical equation. This characteristic of exactness is also the product of the machine itself, whose intrinsic beauties have added to our vocabulary of beauties, and to the high degree of mechanical exactness possible with machine technique. The increased use of machines has, further, increased our appreciation of both their formal and functional virtues. As an example of the latter, the satisfaction to be obtained from driving an efficient motor-car is without doubt partly aesthetic. The surgeon's praise of 'a beautiful operation' is by no means the misuse of the word 'beauty' it might appear to be. The demand for the same aesthetic sensations elsewhere has encouraged qualities of precision and economy in modern design. In architecture theatrical effects of mass, weight and so on, give way to effects of poise and lightness. Accurate structural elimination is the contemporary virtue instead of imposing structural solidity.

This question of solidity brings us to the consideration of the 'factor of safety'. Our greater knowledge of the limitations and capabilities of materials enables us to use them with greater economy and accuracy. There is no longer need for oversizing to allow for ignorance. We no longer believe that exact sizing is not worth the labour of exact calculation. For this advance the refinements of aeroplane design amongst other things have been greatly responsible.

Our whole attitude to the right use of materials has also undergone a certain amount of change. Previously we knew about materials in terms of our own experience with them; we had handled wood and stone – even steel – on a small scale, and knew instinctively when their substance was adequate on a larger scale. In the case of the new synthetic materials, of which reinforced concrete is typical, their properties are not within the bounds of common experience and have to be taken on trust: a new influence in the impersonalization of design. This change does not mean that knowledge of structural properties can be a substitute for visual satisfaction with their adequacy.

. . . Exactness, cleanness, precision of form and finish are the representative modern qualities. They are present in machines themselves as conditions of the machines' functional efficiency. They are present in the products of the machine, partly because the processes of machine manufacture produce these qualities, and partly also in imitation of the machine, from the use of those art forms which study of the machine has contributed. The prevalence of 'streamlining', for example, is an illustration of the influence of a mechanical idiom; its influence being seen in stationary objects where aerodynamic considerations are quite irrelevant.

The distinction must here be made between this influence, which is the unconscious assimilation of an idiom common to our mechanical surroundings, and the deliberate application of a so-called 'modern' idiom: the stylization of modernity producing the *moderne* or 'modernistic', wherein the building or object has applied to it (or is forced into) certain shapes for eclectic or decorative reasons. The result is, of course, no more modern, in the true sense, than my foot – in fact, a good deal less. In the same way that abstract art, directly it loses what might be called the tension or concentration that gives it its aesthetic significance, becomes empty pattern-making without vitality, the vitality of the modern machine product depends on its retaining some of the formal significance of the machine, not on its imitating a few superficial characteristics.

. . . The World Men Carry in their Heads
The aeroplane is a representative modern product. The average piece of architecture, furniture or household equipment is not. To say that the furniture should be more like the aeroplane is so incomplete a statement as to be misleading in its implications: but it should have an affinity with the aeroplane, as the argument of this article sets out to show, because of its dependence on the same conditions of machine production. It can be examined in the light of the same aesthetic, and it has its own duty of contributing to the unity and common direction of the contemporary environment. It must reflect the real, essential world of scientific order that underlies our civilization: the 'world men carry in their heads', of which the aeroplane is a typical inhabitant.

The business of the Modern Movement is to bridge the gulf, as Marcel Breuer has expressed it, 'between appearance and reality'. This gulf is only widened by the make-believe or historical escapade, by the trite formulae of period styles, or by efforts to perpetuate the obsolescent culture of an earlier epoch. We have to start with power and the machine, which dominate our existence. 'Our capacity to go beyond the machine,' to quote Mumford once more, 'rests upon our power to assimilate the machine. Until we have absorbed the lessons of objectivity, impersonality, neutrality, the lessons of the mechanical realm, we cannot go further in our development toward the more richly organic, the more profoundly human.'
[*Architectural Review* December 1935, Vol LXXVIII, pp 211 – 218]

Wells Coates

. . . The requirements of the society we live in must determine the things we make and live with. Our society is above all determined to be free. The love of travel and change, the mobility of the worker himself, grows with every opportunity to indulge it. The 'home' is no longer a permanent place from one generation to another. The old phrase about a man's 'appointed place' meant a real territorial limit: now the limits of our experience are expanding with every invention of science. We move after work, easily, at least within national frontiers; we move for holidays across frontiers; we move away from the old home and family; we get rid of our belongings, and make for a new, an exciting freedom.
. . . The economics of the new ownership create what I call 'programme' planning, the conditions for the operation of which are simple. Let us take an example. A small site is selected, because you must not tie up too much money in any given scheme. It does not matter whether it is for housing or factory development or whatever it may be. No large-scale replanning of never-been-planned areas is permissible. It is one picture – about the relative size of the picture on a postage stamp – you are asked to exhibit in that street; not a galleryful, by the same artist, in a given area. The maximum coverage of site, number of floors and height, carefully specified for you by the authorities, the estate owner, or the client, are to be achieved. The result is more often than not a bewildering geometrical diagram of rooms dimensioned not too strictly in accordance with their function, and often inadequately equipped. Proper orientation is replaced by the questionable advantages of a' view' on to a noisy street or a sordid backyard. On the cash side, the result is to be ten per cent: produced often enough by rigid reduction

estimates during the process of construction, so that the architect's careful attention to detail is reduced outside his control to the minimum requirements of a shoddy building technique, the results of which he can and does prophesy in advance. And when the final product is criticised it is the defenceless architect and not the financial operator, who is made the scapegoat. Financial programme technique of building will produce neither homes nor architecture until people refuse to live with that kind of arithmetic . . .

Until the arithmetic changes, what can architects do with this programme?
. . . It is possible that as architects we can quarrel about styles and details whilst all around us illiterate building is being created, even encouraged, by the lack of co-ordinative laws and principles of land utilisation? Unless, as architects, we set the pace, deliver up the principles for large-scale planning and legislation, we shall not have a chance to create the conditions for an architecture. And you, who are about to become architects, do you remember it is your right to demand that you should also be the geometers of the new land . . .

As architects of a new order, we should be concerned with an architectural solution of social and economic problems, for the tradition of architecture is to seek the response that leads to freedom and fullness of life. How are we to begin to outline the possibilities for the future, or our art? Can you combine the possibilities of a vast extension of human leisure and activity and the consequent enrichment of human values, with an order of life which is set against this basic directive? What are the *material* obstructions here? My time allows me to give you one concrete example or contrast, to illustrate a technical hindrance to the solution of our problem. I sum it up in one statement:

Building costs too much.

Why? Because it has never been properly related to the forms, processes and economics of modern large-scale power production. In its elements, yes: but not as a whole, nor even in units comprising many elements, units of a size suited to the scale of the job. This is so because no one has seriously tackled the job of converting the building industry into a modern industry, in the way, for instance, that the carriage works of yesterday finally produced the modern motor-car.

Let us take an example from this industry. The main essentials of the internal-combustion engined car were fully determined about thirty years ago and a car was produced at that time in small quantities at a cost for a given design of, say £600. This machine possessed a multi-cylinder engine burning petrol mixed with air and ignited by an electric spark; a flywheel, clutch, gears and a transmission system to

the back axle; front-wheel steering; elliptical springing; pneumatic tyres. Lamps, instruments, even the hood, were extras, and you could choose these and other 'accessories' from a long and expensive list. It was a noisy, unreliable, uncomfortable and costly car. But it was new, and gave promise of new enjoyments, new freedoms. The modern motor-car differs in no essential way from the old 'crock' of thirty years ago, so far as its principal elements go: but it is produced today in vast quantities at an actual cost of about £60. It is less noisy than you are when you run down the stairs of your own house; it is reliable (more reliable than most domestic hot-water systems!); it is more comfortable in its seating than most of the chairs you crowd into your tiny living-room; and, in spite of heavy taxes, it is cheap to run, or, at any rate, always worth the money you spend on it. There are no 'accessories' to buy as extras: these are all incorporated, built-in to the standard models. Yet it costs only one tenth the cost of its predecessor, because modern production methods have been perfected in its making. In spite of the lack of modern road systems (the road industry lags behind, with the building industry, in planning and in method), the modern motor-car is less dangerous to human life than is the modern house, as statistics in all countries prove: more people are killed in 'domestic' accidents, in the home, than on the roads, each year.

The design and construction of dwellings today could be said to be at a stage strictly comparable to the design and production of the motor-car thirty years ago. We know what a modern dwelling should include, could include, if it did not cost so much. Yet a home is more important than a motor-car: every living person is qualified, by right, to possess a decent home. Why do we not then begin to build them? The first mass-production car probably cost £500,000 to produce. The first mass-production home would doubtless cost much more than that, and it would take a number of years to produce. And it would include, as a matter of course, all those 'accessories' which today are by the way of being luxuries. It would not be produced for one tenth the cost of the existing ill-equipped house, because in building there are always processes which are not amenable to one-line production; but it would cost only a half, or perhaps a third, of current costs, and would include everything that was needed, everything that every person has a right to possess; and everything would be of the best for its purpose, designed to last a generation or two, or, in certain circumstances, less time than that. For the conditions of modern life determine that we are not persons of 'fixed abode' in the old sense: we go to the work and the life we want, and that might not be near 'home'. And, besides, modern inventions produce new necessitities and appetites:

do we dare saddle an unborn generation with too solid, too 'valuable' a property? This description of a new type of mass-produced dwelling would apply to both individual dwellings and to group-dwellings – flats or apartments. (I hope no 'semi-detached' designs would come off the production line!) The essential characteristics of the planning, amenities, equipment and finishes would be the same. Only in the group-dwellings you would have certain 'extras' on account of insulation between dwelling-units, for instance; matched by certain deductions on account of centralised services, and other economies. And you would plan a large number of standard units capable of assembly in a large variety of forms and finishes and colours. And you would assume (you would have to) that your mass-production methods would be matched by mass-planning methods in siting the new dwellings in new group formations, bearing some ordered relation to your work, your play, your entertainment, and to the systems of communications which link these into a community. And to assume this you would also have to assume a mass-intention towards an ordered and stable society. Given those conditions, you could begin to create an architecture for today.

To this attainment there are requisite Science – the science of the inside of things; science, the identifier, measurer, and calculator; and also Art – the science of the outside of things; art the differentiator, selector and maker. For architecture is both a science and an art.

If we are to consider architecture in the grandest sense as the surest and completest art (and I see no reason why we should not think of it in that way) we know that it simply is not even beginning to be created, and cannot be, because the basic principles of a social plan, an economic plan, of a plan for the division of areas for Work, for Habitation and for Leisure, have nowhere been properly thought out or applied. A great deal of analytical work has been done, but the central problem, the problem of the barriers in the mind of the people and their rulers, is not beginning to be solved. ['The Conditions for an Architecture for today', *Architectural Association Journal*, April 1938, pp 447–57]

J D Bernal

Of all the arts, architecture is the one that has, throughout its history, been most closely connected with science. Indeed, the closeness of this connection may be taken as some indication of the state of excellence of architecture at any period.

. . . To a large extent, modern science itself owes its inception to the interest of the architects.

. . . It was only after the seventeenth century, when both science and architecture became professionalised, that this close personal contact disappeared.

. . . The essential superficiality which marked the decay of architecture in the nineteenth century and still marks school architecture to-day is due to a pre-occupation with appearance rather than structure or function. On the other hand, the scientist had not been forced to consider such problems as the nature of materials and their combination, that an organic link with architecture would have provided. The gothic Cavendish Laboratory at Cambridge and the science museums at Oxford are horrible examples, both from the point of view of appearance and utility, of the complete lack of contact that had been allowed to occur between the architect and the scientist.

There are already happily many signs that this state of affairs is coming to an end. Science is being forced into architecture largely as a result of the necessity for new knowledge to cope with new materials. Another aspect of the same thing is the profound influence that engineering design, particularly of ships and aeroplanes, has had on the standards of architectural taste. At the same time developments which have taken place inside science – particularly those referring to the intimate structure of matter and to new physical methods for determining stresses – are capable of making it of far greater service to the architect than it could have been in the past. The work of the Building Research Station marks the beginning of what may be a new and fruitful phase of intimate collaboration. Nevertheless, almost everything yet remains to be done. The great developments of science in the last hundred years are still for the most part entirely unassimilated by the architects. Science can help architecture in an enormous variety of ways, and in doing so can itself profit from the problems that such collaboration is bound to raise.

Three aspects of architecture
The art of architecture can be considered to have three aspects: the formal, the structural and the functional. Essentially, as the historical development of architecture shows, the order is the reverse of this, functional needs giving rise to structural problems the solution of which falls into formal modes. But science comes into architecture in the first place to explain how things can be done, not what to do, so that the more conventional order seems more appropriate. In each of these what is required is a blend of the new knowledge that science can give with the aesthetic sensibilities and the practical considerations that rule in architecture. In the formal aspect of architecture, the freedom which the new materials provide raises anew the

problems of shape and mass divorced from the normalising influence of well-established tradition. Here science, and particularly mathematics, bears the same relation to architecture as the theory of harmony does to music. No amount of theory will make a man a musician, but there can be no doubt that the existence of musical theory has enormously enriched the possibilities of musical composition. Similarly in architecture, the mutual arrangements of the units of mass and surface in an architectural composition, be it a house, an office block or a town, which must in any case conform to certain geometrical principles, can be manipulated most competently when those principles are understood.

Symmetry
There are two underlying mathematical modes which have recently become more important in science, and are particularly applicable to architecture, namely, those of symmetry and topology . . .

Topology
The importance of topology is probably even greater for architecture than that of symmetry. Topology, which is a rapidly developing branch of mathematics, deals with the special relations of elements independent of their actual or relative distances. It represents the analysis of the connectedness of different parts of space. Now it is principally in a functional aspect that the architect is concerned with connectedness. A problem of the greatest importance in any building is how people can get from one part to another, and this problem becomes of crucial importance in buildings of great size, where the simple solution of equally spaced corridors and staircases definitely breaks down . . .

New materials
A much more practical and easily recognised connection between science and architecture is provided by the new developments in material and structural principles largely due to science. Up till now, however, there has been far too little contact between the needs of architecture and the products of applied chemistry. The great changes that have occurred in architecture have not been due so much to the production of radically new materials as to that of old materials, such as steel or cement, in such quantities and at such a price that they could find quite new uses. But science has now so far advanced that the possibility exists of producing radically new materials and, what is even more important, producing them to specification. It is for the architect to say what are the properties which he requires in

his materials and for the scientist to find or synthesise materials having these properties . . .

Function and design

It is now a commonplace of architecture that the function of a building should play a decisive part in the consideration of its design. Nevertheless, the determination of necessary functions and of the means for carrying out these functions is not an easy task, and requires the intimate collaboration of the architect with a number of different kinds of scientist. The essential point is that the function of all buildings is pre-eminently social, rather than simply biological, utility. A church has the recognised function of being the background for complicated ritual observances, but so, almost to the same degree, has every building. It is, in fact, this essential ritual aspect of architecture that has, until recently, saved the architect from having recourse to the scientist. Because people's lives and their buildings form so closely a part of one tradition, all the architect was required to do was to provide pleasant, though always minor, alterations on well-known themes. Now, however, social forms are changing with the rapidity that quite outstrips the possibility of traditional architectural development, and the architect by himself necessarily proves inadequate to the task, as so many pseudo-modern buildings show. For not only are social demands changing; they are becoming at the same time more rational and definite. The architect is no longer building for the individual taste of a patron but for the requirements of a trust or a town-planning authority. For these purposes it is necessary, in the first place, to have much more definite views as to the function of buildings.

The development of functional architecture is in many ways similar to the organic evolution of the higher animals. First, there is the isolated hut, fulfilling all human social needs at once; then the loose assembly of such unspecialised or partly specialised huts in the family or tribal village; then the house appears, which may be regarded as a partitioned hut or as an agglomeration of huts, each now with a specialised function. Houses in turn aggregate into cities, which have remained unchanged in principle from the dawn of civilisation almost to the present day. But now, with the development of large scale architecture, a new unit is appearing; the building which contains many houses together as flats and many other specialised groups of rooms, shops, cinemas, etc., as well.

Each new organic agglomeration means new functional problems for the architect. The basic unit of functional architecture still remains the room, which may be defined as an insulated equipment space, supplied with communications and various services. It used to be thought that the architect's task ended with providing the four walls of the room with its door, window and fireplace; all the rest was furniture. Gradually, however, the functions of furniture have been taken into the structure of the room itself. Water, heat, light and now increasingly air are being supplied through the framework of the building. All this involves problems in the solution of which the scientist should have as much to say as the architect. Further problems arise in the proper grouping of rooms with different functions.

. . . What I have tried to show in this brief survey is that architecture and science are not two exclusive disciplines, that neither can fully flourish unless it retains a living contact with the other. In the formal, the structural and the functional aspects of architecture science can point the way to new processes, new materials and new arrangements. It is for architecture to use these and combine them into its living tradition. In its turn, science stands to gain by the widening of its field of enquiry and by the appearance of new problems to solve. Finally, since both architecture and science depend for the fulfilment of their latent possibilities on the development of a state of society compatible with that realisation, their interests are jointly involved in securing it. ['Architecture and Science', *RIBA Journal*, 3rd series Vol 44 no 16, June 1937, pp 805–812]

painting and sculpture

All measurements are in centimetres and in all cases height precedes width.

Constantin Brancusi 1876—1957

1 *Prometheus* 1912
Cement, polished; 14 × 17.8
Provenance: formerly collection of Vera Moore
Kettle's Yard, University of Cambridge

2 *Bird in space* 1921—22
Photograph 24 × 18
Provenance unknown
Illustrated in *Circle* no 26, sculpture section
Lent by David Grob

César Domela b. 1900

3 *Untitled* 1938
construction with collage; 36.9 × 46.3
Signed and dated on the reverse
Provenance: Leo Castelli, New York; Bud Holland, Chicago
Lent by Annely Juda Fine Art

Marcel Duchamp 1887—1968

4 *Oculist witnesses* c. 1920
Lithograph; 28.5 × 22.5
Signed 'Rose Selavy' in the stone in reverse
Provenance: purchased in a lot 1936
Private collection

Naum Gabo 1890—1977

5 *Two cubes* 1930
Painted plywood; 30.5 × 30.5 × 30.5 each cube
Illustrated in *Circle* p 103
Provenance: presented by the artist in 1977
Lent by the Trustees of the Tate Gallery

6 *Model for balance on two points* c. 1925
Plastic and rhodoid; 12.7 high
Provenance: property of the artist's family
Illustrated in *Circle* no 3, sculpture section p 125
Lent by Nina Gabo

7 *Stone with collar* 1933 (illustrated p 8)
Stone and plastic; 71.1 high
Provenance: property of the artist's family
Illustrated in *Circle* no 8, sculpture section
Lent by Nina Gabo

8 *Model for spheric theme* c. 1937
Plastic; 10.2 high
Provenance: property of the artist's family
Lent by Nina Gabo

Jean Hélion b. 1904

9 *Ile de France* 1935 (illustrated p 21)
Oil on canvas; 145.5 × 200
Dated and inscribed
Provenance: with Louis Carre, Paris (purchased from the artist 1962); with Leicester Galleries, London 1965; purchased from the Leicester Galleries 1965
Lent by the Trustees of the Tate Gallery

10 *Abstract composition* c. 1935
Oil on canvas; 26.7 × 34.3
Signed on reverse
Provenance: gift of the artist
Lent by Mr & Mrs John Piper

Barbara Hepworth 1903—1975

11 *Two forms* 1934 (illustrated p 22)
Grey alabaster 20.8 high
Provenance: ex collection H R Hepworth
Private collection

12 *Form* 1936 (illustrated p 22)
White marble; 29 high
Provenance: ex collection Mr & Mrs H R Hepworth
Lent by Gimpel Fils

13 *Single form* 1937 (illustrated p 23)
Lignum vitae; 54.6 high
Provenance: property of the artist
Private collection

Arthur Jackson b. 1911

14 *Drawing* 1936
Indian ink on scraper board; 6.6 × 9
Dated and name and title inscribed on reverse
Lent by A J Hepworth, Esq

15 *Drawing* 1936 (illustrated p 24)
Indian ink on scraper board; 7.5 × 9.5
Name and title inscribed on reverse
Lent by A J Hepworth, Esq

16 *Painting* 1937 (illustrated p 24)
Oil on canvas board; 50.2 × 70.5
Name, date and title inscribed on reverse
Lent by A J Hepworth, Esq

17 *Painting* 1939
Oil on board; 49.5 × 52
Name, date and title inscribed on reverse
Provenance: purchased from the artist 1939
Lent by a private collector

Kasimir Malevich 1878 – 1935

18 *Suprematist composition* c. 1916
Pencil on paper; 18.2 × 11
Provenance unknown
Lent by Annely Juda Fine Art

19 *Suprematist composition* c. 1916 (illustrated p 24)
Pencil on paper; 17 × 11.7
Provenance unknown
Lent by Annely Juda Fine Art

Piet Mondrian 1872 – 1944

20 *Composition, white and red* 1935
Oil on canvas on wood; 88.9 × 69.9 including support
signed and dated 'P.M. 35' bottom right
Provenance: bought from the artist at the *Abstract
& Concrete* exhibition 1936
Lent by the Helen Sutherland Collection

Henry Moore b. 1898

21 *Carving* 1935 (illustrated p 25)
Walnut wood; 96.5 high
Provenance: Mrs Irina Moore
Lent by the Henry Moore Foundation

22 *Carving* 1936 (illustrated p 26)
Travertine marble; 45.8 high
Provenance: Mrs Irina Moore
Lent by The Henry Moore Foundation

23 *Square form* 1936 (illustrated p 26)
Green Hornton stone; 34.9 high 30.6 long
Provenance not given
Lent by the Robert and Lisa Sainsbury Collection,
University of East Anglia

24 *Stringed figure* 1937 (illustrated p 27)
Cherry wood and string; 55.9 high
Provenance: Mrs Irina Moore
Lent by The Henry Moore Foundation

Ben Nicholson b. 1894

25 *White relief* 1934 (illustrated p 28)
Oil on carved wood; 35 × 61
Provenance: given to the late Sir Herbert Read by the
artist
Lent by a private collector

26 *White relief* 1934
Oil on carved board; 19.4 × 24.8
signed and dated on the reverse
Provenance: gift of the artist
Lent by Mr and Mrs John Piper

28 *Relief version 1* 1934
Oil on carved board; 20.3 × 30.5
signed and dated on reverse
Provenance: purchased from the artist at the *Abstract
& Concrete* exhibition 1936
Lent by the Helen Sutherland Collection

28 *White relief* 1935
Oil on carved board and built-up wood; 54.5 × 80
Provenance: purchased from the artist 1948
Illustrated in *Circle* no 7 painting section
Lent by the British Council

29 *White relief* 1939 (illustrated p 29)
Oil on carved board; 77.5 × 73.5
signed and dated on reverse
Provenance: formerly collection of Winifred Nicholson
Lent by a private collector

Winifred Nicholson 1893–1981

30 *Quarante-huit Quai d'Auteuil* 1935 (illustrated p 29)
 Tempera on wood; 67.8 × 100
 Inscribed on reverse 'Winifred Nicholson Dacre 1935'
 Provenance: purchased from the artist 1975
 Illustrated in *Circle* no 31 painting section
 Lent by the Trustees of the Tate Gallery

Antoine Pevsner 1884–1962

31 *Cork painting* 1930?
 Cork, plastic, paint; 49.5 × 45.7
 Signed and dated in lower right hand corner,
 date illegible
 Provenance: given by the artist to his brother,
 Naum Gabo
 Lent by Miriam Gabo

John Piper b. 1903

32 *Abstract I* 1935 (illustrated p 30)
 Oil on a collage of canvas on plywood; 71 × 88.5
 Inscribed on reverse 'John Piper. Painting 1935'
 Provenance: purchased from the Redfern Gallery 1954
 Illustrated in *Circle* no 25 painting section
 Lent by the Trustees of the Tate Gallery

33 *Painting* 1936
 Oil on canvas; 152.4 × 183
 signed and dated on reverse
 Illustrated in *Circle* no 26 painting section
 Lent by Mr and Mrs John Piper

John Cecil Stephenson 1889–1965

34 *Painting* 1937 (illustrated p 31)
 Tempera on canvas; 71 × 91.5
 Dated and inscribed 'John Cecil Stephenson 1937 36" 28"
 Egg Tempera Painting 1937'
 Provenance: purchased from the artist by the
 Marlborough New Gallery, London 1963;
 purchased from the Marlborough New Gallery,
 London 1963
 Lent by the Trustees of the Tate Gallery

Vladimir Tatlin 1885–1953

35 *Contre-relief* c. 1917
 Painted wood, steel sheet treated with oil and carbon;
 70 × 38 × 20
 Provenance: original assumed lost; reconstruction by
 Martyn Chalk 1982, 1 of 3
 Illustrated in *Circle* no 21 sculpture section
 Lent by Martyn Chalk

Friedrich Vordemberge-Gildewart 1899–1962

36 *Composition no 94* 1935 (illustrated p 31)
 Oil on canvas; 100 × 80
 Provenance: estate of the artist
 Lent by Annely Juda Fine Art

architecture

The organisation of the architectural section of the exhibition

The diversity of the work of the 27 architects whose work is illustrated in Circle presents a challenge to any exhibition of the architectural contribution to the journal. The range of architects who were invited to send work was, by design, very wide. There was, as Leslie Martin makes plain in the introduction to this catalogue, no intention of issuing an architectural manifesto: instead Circle was to illustrate the work of a broad front of architects working on common themes and all in sympathy with the 'Constructive Idea'.

Despite the number of architects whose work was included, the list of contributors is not just a 'roll-call' of architects sympathetic to a modern architecture. Consider the selection of the work of English architects. The omission of work by Thomas Tait, Oliver Hill and Grey Warnum is hardly surprising: they are of an earlier generation than the young radicals of MARS and their work could plausibly be dismissed as an opportunistic application of modernistic styling. Even the older supporters of the New Architecture like Howard Robertson and Joseph Emberton, both excluded by Wells Coates from MARS as too eclectic in their interests, do not appear in Circle.

By contrast, there are a number of surprising omissions. The work of Connell, Ward and Lucas was not illustrated, although their houses clearly reflected the ideas of the continental avant-garde, and both Ward and Connell were committee members of the MARS group. Surprising too, is the absence of any work by Wells Coates. As the chairman of MARS and well known both as an architectural designer (Lawn Road flats), a designer of furniture (Isokon) and other products (the Ekco radio), he was one of the leaders of the new approach in England. But neither these omissions, nor the absence of work by acknowledged continental leaders of the New Architecture like Mies van der Rohe, weaken the force of Circle's presentation of the 'constructive idea'. The purpose of the journal was to bring together work generally representative of the new direction, not, as groups like De Stijl or MARS tended to do, to divide the architectural world rigidly into the chosen few and those beyond the pale.

In the exhibition this variety of interests is represented in three ways:

First by means of a mosaic of photographs of a selection of the work of all the architects who submitted work to the journal.

Second, to illustrate a number of the themes common to the work in the architectural section of Circle we have selected four buildings for more detailed display. Our selection is made from the work of architects whose work appears in Circle but is not restricted to the particular buildings illustrated in the journal. They are: the Tuberculosis Sanatorium at Paimio by Alvar Aalto; 'Bentley Wood' near Halland in Sussex by Serge Chermayeff; the Finsbury Health Centre by Tecton, and Impington Village College by Walter Gropius and Maxwell Fry. They exemplify a number of themes: the international dimension of the 'constructive idea', the potential of the new materials and the new technology, the relationship of the New Architecture to design in other fields such as furniture, and the new and ideal setting offered by the New Architecture to the social needs of the community.

Finally we have created a 'mock-up' of an interior furnished in keeping with the 'constructive idea', using furniture, fabrics, and equipment by architects and designers associated with Circle. The selection has been guided by the range of designs set out in The Flat Book, published by Sadie and Leslie Martin in 1939, which not only presents information on manufacture and price, but also sets out (as had Franz Schuster's Wie richte ich meine Wohnung ein?, 1930) basic principles for the arrangement of furniture and equipment, and choice of finishes in each type of room. NB

37 Alvar Aalto: Tuberculosis Sanatorium, Paimio, Finland Competition 1929; construction 1930–33

The Paimio sanatorium serves as a reminder of the importance of the international dimension in the architectural interests of *Circle*. At a time when the New Architecture was first appearing in Britain, Aalto in Finland (and Honzig and Havlicek in Czechoslovakia, and Syrkus, Helena and Szymon in Poland) was experimenting with the ideas developed by the French and German avant-garde. Designed only two years after Aalto's first experiments (with Bryggman) in the new manner, the sanatorium shares a number of close parallels with Duiker's design for the Zonenstraal Tuberculosis sanatorium at Hilversum which Aalto had seen in 1928. In the overall form of the sanatorium, Aalto diverges from the rectilinear geometry typical of the mainstream of the New Architecture and pursues a more informal approach to planning. However in the smooth treatment of the facades, and the bold use of the possibilities of the concrete frame, Aalto uses the forms of the New Architecture with assurance, and success. *NB*

Model by Nicholas Bullock
scale 1:500

38 Serge Chermayeff: the architect's own house, 'Bentley Wood' near Halland, Sussex; 1935–38

Like a number of other modern houses in the early 30s, the design was at first opposed by the local planning authority both because of its siting, and because of its flat roof and supposedly insubstantial timber construction. However, the architect appealed successfully, arguing that the timber frame system of construction was an extension of the local vernacular use of timber frame building.

The timber frame, expressed on the garden elevation with classical simplicity, makes possible a free-flowing connection between exterior and interior which is further emphasised by the continuity of floor surface and external paving. The interiors convey a sense of the simple luxury that could be achieved with the furniture and equipment already available in the new manner, and reflect the desire, shared by many of the younger architects of the time, to create a consistent overall approach to design using mass-produced and readily available products. In 1937, it was already possible, even in England, to satisfy the demands that Muthesius had made of the Werkbund in 1911: to develop an approach to design which would extend from 'the sofa to the city'. From the furniture, designed by Breuer, Aalto, Mies van der Rohe, and by Chermayeff himself, to the design and construction of the complete building, the Halland house demonstrates convincingly the unity of design for which *Circle* was calling.

Model by Nicholas Bullock
scale 1:100
Photographs reproduced by kind permission of the *Architectural Review*

39 Walter Gropius and Maxwell Fry: Impington Village College; 1937–39

Gropius and Fry's design for the Village College at Impington is of natural interest because it provides a convenient local example of the idea of the New Architecture. The design exemplifies the 'elemental' approach adopted by a number of architects whose work is illustrated in *Circle*; this approach was much favoured by the avant-garde architects for school design and found a natural application in the 'pavilion' layouts of the time. As in Gropius and Fry's design for a school at Papworth, the different 'elements' of the design, the hall, the classrooms, and the connecting circulation are clearly articulated in plan, and in their three-dimensional and constructional treatment.

The village college at Impington also demonstrates the way in which the New Architecture was intended to be set in the service of society to provide the most suitable environment for all the needs of the community. In education, the potential of the New Architecture, combined with new ideas on the role of the school in society, held out the promise of a radically new approach to school building. Under the leadership of S E Urwin, Cambridgeshire had already developed a progressive approach to school design and the combination of Henry Morris's ideas on the village college and Gropius and Fry's design at Impington was one of the last in this series of bold experiments before the war. *NB*

Model by Kim Randall
scale 1:200
Photographs reproduced by kind permission of the *Architectural Review*
Drawings lent by Cambridgeshire County Council and RIBA Drawings Collection

40 Tecton: Finsbury Health Centre; 1937–38

Set in one of the poorer areas of London, the Health Centre illustrates clearly the potential social benefits of the New Architecture. In place of the Borough's scattered health facilities (TB clinic, disinfecting station, dental clinic, foot clinic, solarium and mortuary), many of them located in inadequate and dilapidated premises, the new health centre offered a single central location and a new and positive image for the Borough's health care service. The building was conceived, by both client and architects, as a 'megaphone for health'. It was to offer care and assistance in modern and cheerful surroundings, advertising its different functions in the bold and colourful forms of Gordon Cullen's mural and in the clarity of the organisation of the different clinics and the public's access to them through the light and airy reception spaces.

The clarity that Tecton sought in the overall layout of the building is equally evident in the detailed design and construction of the centre. The relationship of structure to the arrangement of spaces ensures a valuable flexibility in planning. The planning of structure and services makes change and replacement possible without major alteration. Despite considerable progress in medical practice, and damage during the war, the building still continues in use as a health centre, operating along much the same lines as originally conceived. *NB*

Model by Amy Sargeant
scale 1:100
Photographs reproduced by kind permission of the *Architectural Review*

Circle interior
The following items will be included in the 'mock-up' interior:

Alvar Aalto

41 *Stool with back* c.1933
Plywood
Lent by a private collector

42 *Table* c.1933
Plywood
Lent by a private collector

43 *Chair* c.1933
Plywood
Lent by a private collector

44 *High back chair* c.1933
Plywood with upholstered cushion
Lent by a private collector

R D Best

45 *Bestlite Floor Lamp* 1982
Lamp has a universal joint at the head of an arm.
Reflector can be turned back on itself. Chromium-plated
tube and painted spun aluminium
Based on the design by R D Best c.1932–3
Lent by Best and Lloyd Limited

Marcel Breuer

46 *Long chair* (Isokon) 1936
Laminated wood and upholstered cushion
Lent by a private collector

47 *Long chair* 1935
Aluminium
Lent by a private collector

48 *Nesting tables* (Isokon) 1936
Plywood
Lent by a private collector

Wells Coates

49 *Tray* c.1933
Plywood
Lent by a private collector

50 *Stool* c.1933
Plywood
Lent by a private collector

51 *Ekco radio AD36* 1936
Bakelite
Lent by Pye Ltd (Cambridge)

Ben Nicholson

52 *Design of rectangles and triangles* c.1933
Block printed cotton
Geometric pattern of horizontal stripes incorporating
black rectangles, black triangles, white rectangles and
black dots. Fabric bordered by red stripes.
74 long (made into a pillowcase)
Lent by a private collector

53 *Vertical* 1937
Jacquard woven cotton and rayon
Geometric pattern incorporating vertical red stripes
with horizontal geometric shapes (circles and squares)
Length 274
Edinburgh Weavers, Carlisle
Lent by the Whitworth Art Gallery, University of
Manchester

54 *Vertical* 1937
Jacquard woven cotton and rayon
Geometric pattern incorporating vertical stripes,
L shapes and circles within rectangles in white
Length 274
Edinburgh Weavers, Carlisle
Lent by Jocelyn Morton

art and life

55 Production Photographs of *Seventh Symphony*
Designed by Christian Bérard, 1938
From *Dancing Times* August 1938, pp 514–15

56 **Abstract & Concrete**
An exhibition of Abstract Painting and Sculpture Today
A brochure announcing the exhibition and launching an
appeal to fund the project
Text by Nicolette Gray
2pp illustrated
Lent by Nicolete Gray

57 **Abstract & Concrete**
*An exhibition of Abstract Painting & Sculpture, 1934 &
1935*
Held at 41 St. Giles, Oxford 15–22 February 1936
A checklist, with prices and a list of sponsors
2pp, no illustrations
Lent by Nicolete Gray

58 **Abstract & Concrete**
*An international exhibition of Abstract Painting &
Sculpture Today*
*Arranged by Mrs Basil Gray and AXIS in conjunction
with Alex. Reid & Lefevre, Ltd, St. James's, London*
No dates given
Catalogue with a foreword by Nicolette Gray,
a checklist of exhibits and a list of sponsors
4pp, no illustrations
Lent by Nicolete Gray

59 **Axis**
*A quarterly review of contemporary 'abstract' painting &
sculpture*
Edited by Myfanwy Evans
*Issue no 5 Spring 1936: International exhibition of
abstract painting sculpture and construction*
32pp illustrated
Kettle's Yard, University of Cambridge

60 **Constructive Art**
Catalogue to an exhibition held at the London Gallery
July 1937
Foreword by J L M (Martin)
Additional text by Siegfried Giedion
8pp unnumbered including cover
Lent by the Courtauld Institute of Art

61 **Barbara Hepworth**
Catalogue to an exhibition held at Reid and Lefevre
October 1937
Introduction by J D Bernal FRS
8pp, no illustrations
Lent by the Courtauld Institute of Art

62 Letter from Barbara Hepworth to J D Bernal (undated)
Refuting his criticisms of her sculpture
Lent by the Syndics of The University Library, Cambridge

63 Photograph of a Victoria Regia lily leaf (underside)
by K Honzig (reproduced in *Circle* p 260)

László Moholy-Nagy 1895–1946

64 *Humber Dock Street* (eastward) 1937
Humber Dock Street (southward) 1937
Humber Dock Street (westward) 1937
*Nelson Street: from Horsewash ramp and moored keel
boat* (n. westward) 1937
*Nelson Street: from Horsewash ramp and moored keel
boat* (n. westward) 1937
Hull Central Dry Dock 1937
Lent by Terence Senter

65 'Paths to the unleashed colour camera'
The Penrose Annual 39, 1937, pp 26–27
Lent by The Syndics of the University Library, Cambridge

66 'Light-Architecture'
Industrial Arts I, i, 1936, p 17
Lent by The Syndics of the University Library, Cambridge

67 **Moholy-Nagy**
Catalogue to an exhibition held at the London Gallery
December – January 1936–37
Introduction by Siegfried Giedion
40pp, 11 illustrations
Lent by the Courtauld Institute of Art

68 Letter from László Moholy-Nagy to J D Bernal
25th May 1937
Thanking him for his hospitality in Cambridge
Lent by The Syndics of the University Library, Cambridge

Ben Nicholson

69 *First Scheme for Massine Ballet* 1934
Oil on card mounted on board; 8.2 × 13.9
Dated and inscribed on reverse 'for Jim from Ben,
first scheme for Massine Ballet 1934'
Provenance: Gift to H S Ede from the artist
Kettle's Yard, University of Cambridge

70 *Project for Massine's Seventh Symphony* 1934
Signed and dated on reverse 'Ben Nicholson 1934'
Provenance: gift of the artist
Lent by Lady Summerson

71 *Ben Nicholson*
Brochure for an exhibifion held at Reid and Lefevre
March 1939
4pp
No text, no illustrations
Lent by the Courtauld Institute of Art

Jan Tschichold

72 *Typographische Gestaltung*, Benno Schwabe, Basel,
1935
This copy has Tschichold's notes in English for a
proposed English edition which was not realised.
Ruari McLean's translation was published by
Lund Humphries in 1967
Lent by the St Bride Printing Library

73 'Abstract Painting and the New Typography'
Industrial Arts I, ii, 1936, pp 160–161
Lent by The Syndics of the University Library, Cambridge

74 *Typographical Work of Jan Tschichold*
Lund Humphries, London, November/December
1935
Lent by Messrs Lund Humphries

75 *The Penrose Annual* 40, 1938
The cover, layout and typography was designed by
Jan Tschichold
Lent by The Syndics of the University Library, Cambridge

76 Model of a Felspar Crystal
The structure of this crystal was published in 1933
by W H Taylor
Lent by the Department of Physics, University of
Cambridge